IMAGES
of America

EARLY LAS VEGAS

D0808091

IMAGES
of America

EARLY LAS VEGAS

Dr. Linda Karen Miller

ARCADIA
PUBLISHING

Published by Arcadia Publishing
Charleston, South Carolina

Printed in the United States of America

Library of Congress Control Number: 2012950167

For all general information, please contact Arcadia Publishing:
Telephone 843-853-2070
Fax 843-853-0044
E-mail sales@arcadiapublishing.com
For customer service and orders:
Toll-Free 1-888-313-2665

Visit us on the Internet at www.arcadiapublishing.com

*To the legacy of Helen J. Stewart, who dreamed
of a town and helped to build it.*

CONTENTS

FOREWORD

Helen J. Stewart, called "the First Lady of Las Vegas" by longtime resident Delphine Squires, owned and operated the Las Vegas Rancho from 1881 until its sale in 1902 to Montana senator William Andrews Clark. Her extraordinary life has been kept alive by author and historian Dr. Linda Miller, who, in costume of the period, remarkably represents Helen J. Stewart both in speech and presentation. Las Vegas organizations and their members feel as if they actually know Helen J. Stewart, feel her passions, and share her hardships because of Dr. Miller's historic revelations, and perhaps, Helen J. Stewart truly is "the First Lady of Las Vegas!" Without her courage and perseverance, burying her murdered husband while pregnant with her fifth child, Senator Clark might never have brought his railroad to Las Vegas. She not only held onto the ranch but had also increased its size by 1890. She bought detached and adjoining properties until she was the largest landowner in Lincoln County.

As prospective buyers awaited the land auction in 1905, many of them camped on the Las Vegas Creek near the Las Vegas Rancho. Always the warm, outgoing hostess, Helen J. Stewart made sure they had access to the fruit her orchards bore. Early Las Vegans, miners in El Dorado Canyon, and travelers from Utah and California, all were well received as guests in her home and provided with supplies for their journey.

Helen J. Stewart helped found the Nevada Historical Society in 1904, serving as the president of the southern branch in 1908. She was postmaster of the post office located on the Las Vegas Rancho property. She was elected as the first female member of the school board and was a charter member of the Mesquite Club; she presented that early organization with a gavel made from the native mesquite wood. During her membership period, the Mesquite Club provided Las Vegas with its first library.

Mrs. Stewart's son William and his wife had a daughter with special needs who was named for her grandmother. The Helen J. Stewart School in Las Vegas was named for this child. The gracious elegance shown by Dr. Linda Miller in her public presentations mirrors the phenomenal life of Helen J. Stewart and keeps the image of this First Lady of Las Vegas, indeed the representative of pioneer life, teeming with historical accuracy.

—Donna Andress
author and historian

ACKNOWLEDGMENTS

I want to thank the University of Nevada, Las Vegas (UNLV) Libraries Special Collections Department, especially Kelli Luchs and Su Kim Chung, for having seen me through several projects for a decade. Also thanks to Peter Michel, also of Special Collections for his help in understand the Union Pacific files. Also, I thank Dennis McBride, director at the Nevada State Museum Las Vegas, and Mark Hall-Patton, director of the Clark County Museum. Both have been constant supporters of all my historical endeavors. Mandy Keefer, interpreter at the Spring Mountain Ranch State Historic Park, was especially helpful in finding unknown photographs. Special thanks to Robert Nylen, curator of history at the Nevada State Museum in Carson City for reviewing my manuscript. Thanks also to Joe Thomson, western historian, who helped me understand pioneering Las Vegas families.

The history of the town is recreated today during Helldorado Days, which have been reinvigorated after several years of stoppage, due to the efforts of Esther Carter, executive director of the Las Vegas Centennial Commission, and Oscar Goodman, former mayor, who helped recreate the land sale in the 2005 centennial celebration. Funds from the centennial license plates are used for historic preservation. Many thanks go to Mayor Carolyn Goodman, who has continued her husband's preservation interests and appeared at the Helen J. Stewart statue dedication.

INTRODUCTION

John C. Fremont put Las Vegas on the map after camping there in 1844. More than 20,000 copies of this map were published and distributed. Las Vegas became an important stop on the way West. Mormon settlers brought wagons to Utah over his route, and the first railroad through the region obtained water for steam engines from the creek formed by the Las Vegas Springs that Fremont publicized.

The Mormons colonized Las Vegas in 1855 as part of the church's westward expansion. It served as a way station for travelers between Salt Lake and Southern California. The Las Vegas Valley was an oasis in the harsh desert environment, with artesian springs and meadows providing water and feed for animals.

Mineral deposits at Mount Potosi and El Dorado Canyon brought renewed activity to the Las Vegas Valley. These mining camps created a need for fresh produce, and several farms sprung up. Ranches grew around the natural springs. The largest, most significant ranch was the Las Vegas Rancho on the grounds of the Old Las Vegas Mormon Fort. The location of the ranch made it prime real estate. But ranching in Southern Nevada and other Western states was a hard life.

When it became evident that a railroad was certain to cross the valley, local rancher Helen J. Stewart began buying up land. In 1902, she sold over 1,800 acres to Montana senator William A. Clark of the San Pedro, Los Angeles & Salt Lake Railroad. With the coming of the railroad, Las Vegas became a town. By 1904, a tent town sprung up a half-mile west of the ranch.

As civilization came to this isolated place in the desert, church spires, schools, and men's and women's clubs developed. The town faced railroad strikes, economic downturns, fires, floods, and other catastrophes. The old fort was turned into a testing lab for the cement for Hoover Dam. However, the town survived thanks to the many pioneer people who helped to build it.

Today, those "pioneer days" are retold through parades and historical interpreters. Enjoy your walk back into the old days of early Las Vegas.

One

EXPLORATIONS AND A
MORMON SETTLEMENT

Las Vegas's main thoroughfare is aptly named Fremont Street after John C. Fremont, who camped there May 3, 1844, and mapped a later version of the Old Spanish Trail through Las Vegas. He thought he was on the trail when he followed a rugged path eastward over Mountain Springs Pass between Pahrump and Las Vegas Valley. He recorded it in his report, which received wide distribution.

In 1855 a group of thirty Mormon missionaries established a short lived colony at the Mormon Fort along the spring fed creek. On June 15, the missionaries assembled to give thanks and pray for the future. That event marks the beginning of the city of Las Vegas and is still celebrated today. They constructed a 150-square-foot fort to provide a mail stop between Salt Lake City and Los Angeles.

Las Vegas began as a rest stop for travelers on the Old Spanish Trail. The city got its name from a group of springs that once offered a welcomed oasis in the desert. This was a way station for overland travelers on the Mormon Trail, which connected Mormon Utah and California settlements, also helping the native Paiutes. The site disbanded in 1857.

As mining increased in the 1860s, miners came into the area. Ranchers moved in and traded with the miners. Nevada's request for a boundary extension to the east and the matter of Pahranagat mines became inseparably mixed. A bill to annex additional territory to Nevada passed the US Senate in 1865 but failed in the House of Representatives. In 1866, Congress granted it subject to approval of the Nevada legislature.

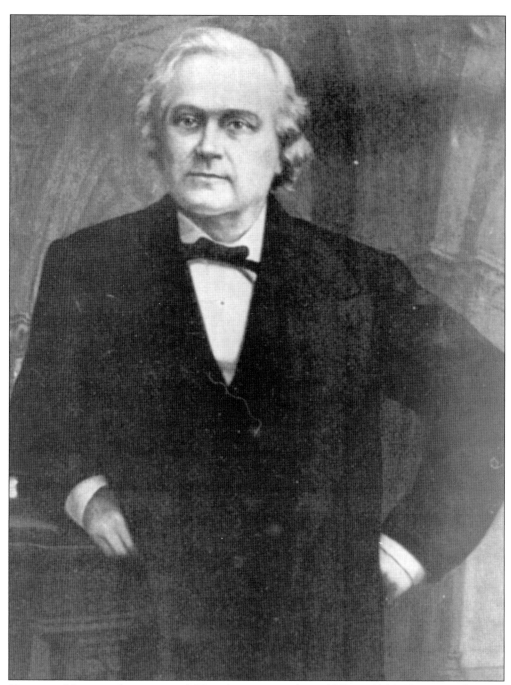

Governor Nye was the territorial Nevada governor from 1861 to 1864. However, the area containing Las Vegas did not become part of Nevada until January 18, 1867. In March 1861, a Nevada territorial bill passed through Congress and was signed by Pres. James Buchanan at the end of his term in office. A few days later, when Pres. Abraham Lincoln took office, he chose a political ally, James Nye, to serve as governor of the Nevada Territory. On October 31, 1864, Lincoln proclaimed Nevada a state. Shortly thereafter, Nevadans voted Lincoln back into office. (Courtesy of UNLV Libraries Special Collections.)

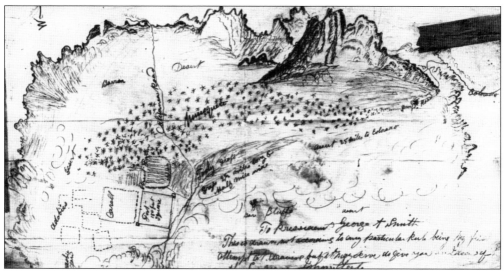

This drawing of the fort was done by one of the original Mormon settlers, John Steele. His map shows Las Vegas as a small island of settlement in a vast area of desert. On June 19, 1855, he wrote, "To the left of the fort are slender rectangular numbered gardens." His journal has a detailed description of the life of the settlers during their 18-month stay, before being called back to Utah. (Courtesy of UNLV Libraries Special Collections.)

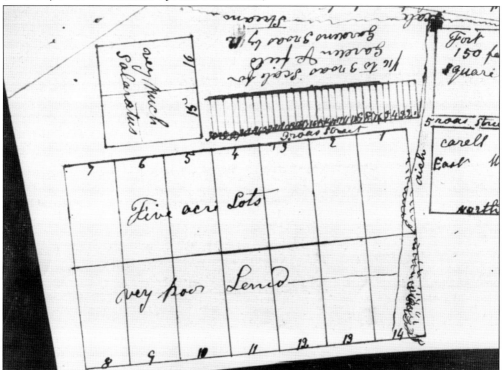

Every man was assigned a garden plot irrigated by water from the nearby creek. They planted orchard trees. The Paiutes helped in the fields, as corn and other plants thrived. However, the alkali soil stunted the growth of crops. Crop failures, difficulties in mining, and internal squabbles led to the abandonment of the settlement in 1857. (Courtesy of UNLV Special Collections.)

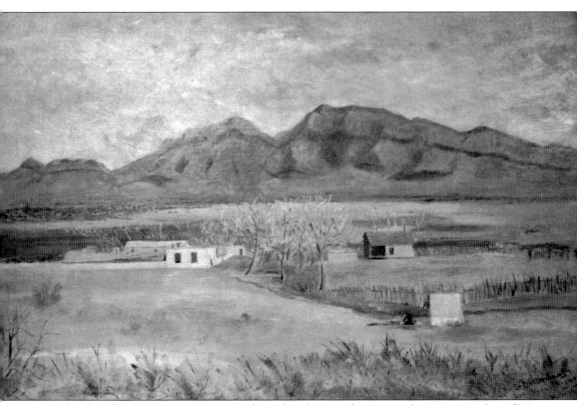

Frederick Dellenbaugh was an artist and a Colorado River historian who was a member of Maj. John Powell's second expedition from 1871 to 1872. On March 16, 1876, Dellenbaugh climbed the hill west of the main ranch building and made this sketch. The vast mesquite bush extended from the fort, down the Las Vegas wash, to the base of Sunrise Mountain, and spread out to Colorado. He later finished it in oils. It is the earliest known painting of the area. (Courtesy of Nevada State Museum Las Vegas.)

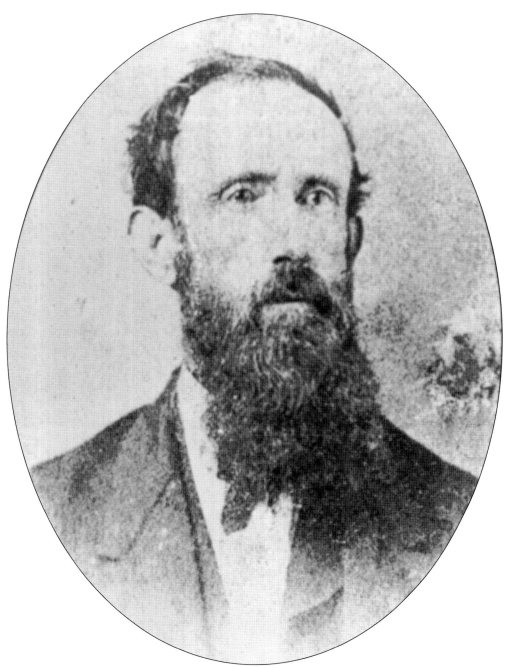

In 1865, El Dorado Canyon miner Octavius Gass began operating a store and blacksmith shop to serve overland travelers and also began raising cattle on the ranch grounds of the abandoned Mormon fort. A letter from 1867 states that an Army officer from El Dorado bought 1,500 pounds of oat hay at 3¢ per pound. Gass bought the Las Vegas Ranch with Nathaniel Lewis and Lewis Cole, and then bought them out in 1872, which began his downward financial spiral. Gass was heavily in debt and borrowed $5,000 in gold from Archibald Stewart to pay back taxes on the ranch in 1879. He defaulted twice on the loan. The Stewarts took over the property and moved to Las Vegas from Pioche in 1882. (Courtesy of UNLV Libraries Special Collections.)

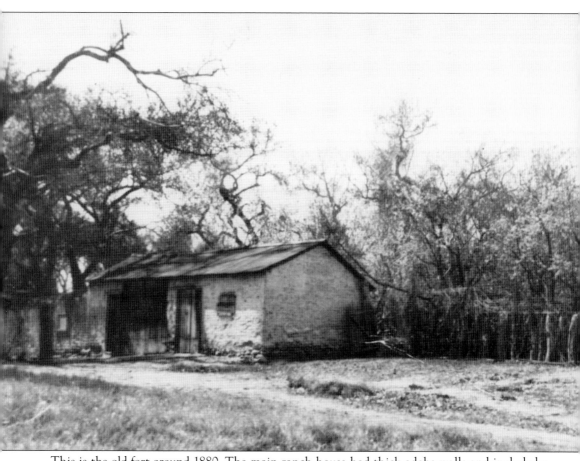

This is the old fort around 1880. The main ranch house had thick adobe walls and included a bedroom, kitchen, and living room. During the time of Gass, a 20-foot table in the middle of the dining room sat 15 people. Much of this building was the former southwest corner of the old Mormon fort. (Courtesy of UNLV Libraries Special Collections.)

Two

A WAY STATION FOR TRAVELERS

Las Vegas continued to be a watering hole for travelers on the Mormon Trail and the site for early ranching and mining. All teams stopped here, coming and going east and west. Dusty travelers asked where to camp. They parked their wagons along the creek or upper springs, four miles to the west where water and grass were abundant. They found shade and protection under the cottonwoods.

The geography of the Las Vegas Valley was well known by the turn of the century. The only permanent settlers were the ranchers at the cross roads of trails leading across the desert and into the mining districts and up to Mount Charleston. The most prominent of these ranches were owned by O.D. Gass and later the Stewarts.

Helen Stewart and her husband, Archibald, took over the Las Vegas Rancho in 1882 when Octavius Gass defaulted. Helen raised five children on the ranch. As the owner of the ranch following the death of her husband, she overcame misfortune to become an able rancher and businesswoman. She helped transform Las Vegas from a desert watering hole into a vigorous young town. (Courtesy of UNLV Libraries Special Collections.)

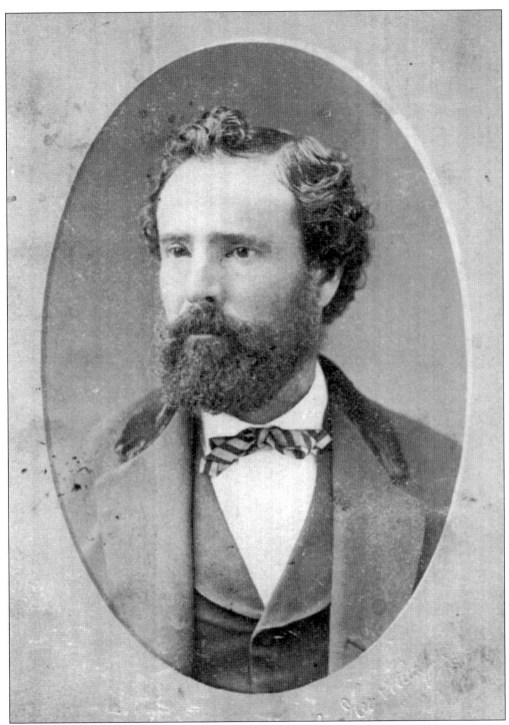

Archibald Stewart was Helen Stewart's first husband. He was murdered July 13, 1884, at the Kiel Ranch; his murder still remains unsolved. Helen continued to live at the ranch, as it became a resort for travelers and miners. She charged $1 per day for board, shade, milk, a good bed, and a clean table. (Courtesy of UNLV Libraries Special Collections.)

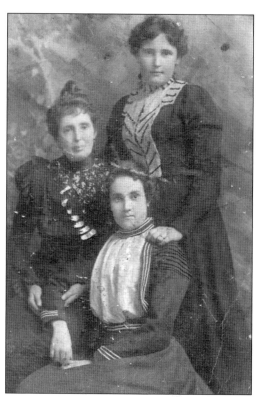

Helen J. Stewart (left) is pictured with her daughters Evaline (standing) and Tiza (sitting). The correspondence between Tiza and her mother over several years gives an insider's view of daily life in early Las Vegas. Evaline moved in with her mother after the birth of her child from her second marriage. (Courtesy of UNLV Libraries Special Collections.)

This photograph depicts a postal rider delivering mail. The first postmaster of Las Vegas was named in 1893. The certificate is currently on display in the Nevada State Museum in Las Vegas. (Courtesy of UNLV Libraries Special Collections.)

The Las Vegas Ranch was used to raise horses, cattle, and other livestock, as well as to grow crops. Cattlemen came from as far as Wyoming to buy cattle, traveling for 10 days before arriving at their destination. Structures erected at the ranch before 1902 included "one canvas covered store house, one adobe chicken house and one adobe store house." In the 1902 land sale, there was an unspecified number of cattle and horses. (Courtesy of UNLV Libraries Special Collections.)

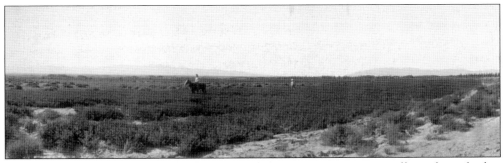

This image depicts the ranch around 1900. Three crops came in annually—wheat, barley, and oats. Harvesting came in late summer and was usually done by Native American women. Unfortunately, agriculture never became a strong cash crop due to the high alkalinity deposits in the soil. (Courtesy of Library of Congress, American Memory.)

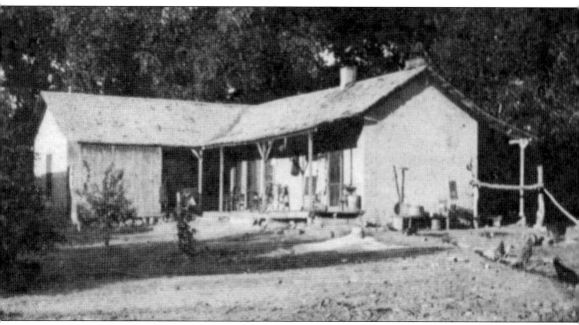

Shown here is the main ranch house, built with thick adobe walls. It had an L-shaped floor plan with a pitched roof. Running from north to south, a new wing was added. Porches were provided on the east and west sides of the addition. The porch also extended along the north side of the original building. The house included a bedroom, kitchen, and living room. Two bedrooms were added later and connected to the kitchen. There were a storage building and blacksmith shop on the property. (Courtesy of UNLV Libraries Special Collections.)

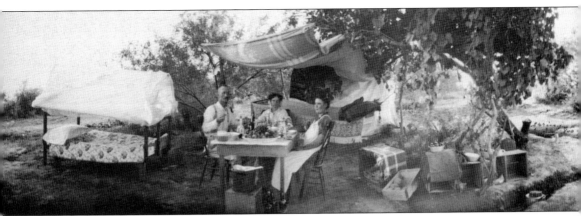

The Mormon Trail from Salt Lake City brought travelers to and from Southern California. Las Vegas Creek flows alongside the row of cottonwood trees. Women washed and mended clothes along the creek and bought milk, vegetables, and beef from the local ranchers. Tent travelers usually only stopped for a day or two in one spot along the creek. (Courtesy of UNLV Libraries Special Collections.)

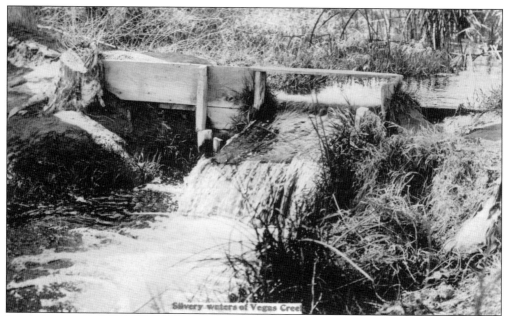

It was this spring-fed creek that brought many visitors to stop at the Las Vegas Ranch. Following the land sale, the creek became polluted because of hogs wallowing in the water. This was a problem for the dairy cows still being raised at the ranch. (Courtesy of UNLV Libraries Special Collections.)

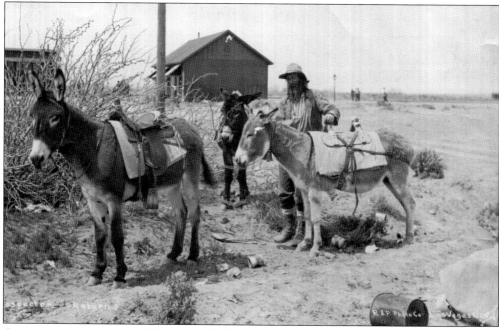

A prospector returns to Las Vegas in 1905. Prospectors from El Dorado Canyon often came into town to buy vegetables and beef. Without the mines, Nevada's railroads and rail towns, like Las Vegas, may have never been built. Mining was the principal industry and helped Southern Nevada's earliest ranchers prosper. El Dorado Canyon north of Searchlight was a busy mining scene. (Courtesy of UNLV Libraries Special Collections.)

Pictured is the old Stewart Ranch around 1920 with a row of cottonwood trees. During Stewart's time, the ranch became a minor business and communication center for the entire southern portion of Lincoln County. A foreman directed the ranching and farm activities. The ranch became a sort of resort for Southern Nevada prospectors and miners. (Courtesy of Nevada State Museum Las Vegas.)

This is an orchard on the Stewart Ranch. Water was applied to irrigate the soil, and fertility became apparent. Helen Stewart planted orchards and introduced new varieties of fruit, shade trees, and garden plants. She developed several new fruit tree varieties specifically for the desert climate. The fruits were made into jams for the Christmas holidays. (Courtesy of UNLV Libraries Special Collections.)

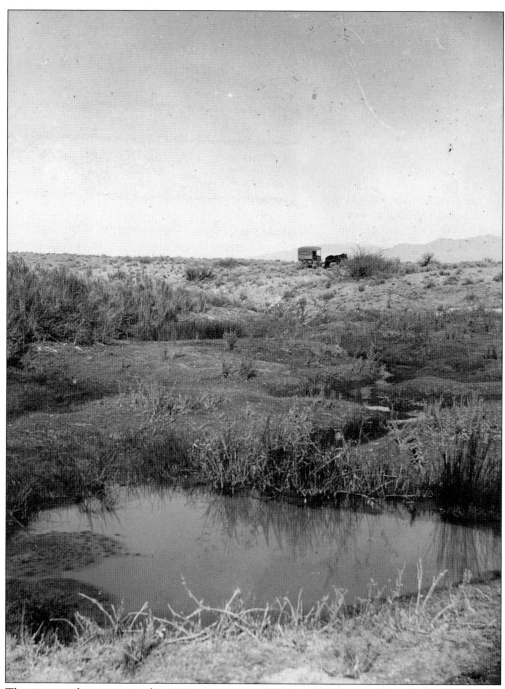

The sign on the wagon in this 1900s scene says, "Grocers / El Dorado Store," and "540 South Spring Street." The image depicts the ranchers' connection in supplying the miners in El Dorado with food. Farmers came to supply the needs of the occasional traveler and prospector. (Courtesy of Nevada State Museum Las Vegas.)

Pictured is Conrad Kiel's ranch house. He and his son Ed lived in this two-room cabin on the small ranch. It was located two miles away from the Stewart Ranch and was known as a haven for outlaws. It was here that Archibald Stewart was murdered on July 13, 1884. (Courtesy of Nevada State Museum Las Vegas.)

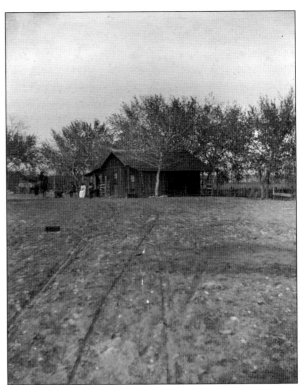

Conrad Kiel is seen on his ranch. He had great fig trees. He had the first artesian well on his property, used for irrigation purposes. He also had a sawmill in Kiel Canyon. Ranchers used the sawmill in the heavily timbered Charleston Mountains, located 30 miles northwest of the ranch. After a tree was felled, Kiel wrapped a rope several times around the timber and rolled it toward the mill. (Courtesy of UNLV Libraries Special Collections.)

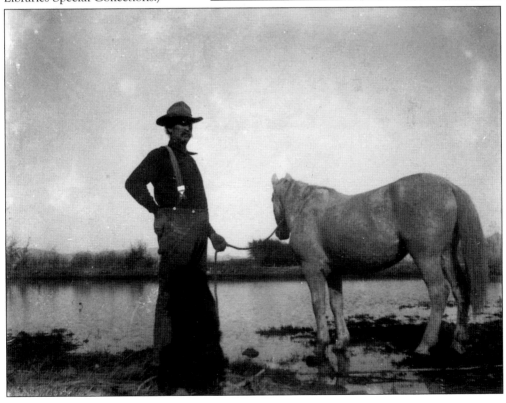

Here is Jim Wilson with two sons Jim Jr. and Tweed at his Spring Mountain Ranch. After their father's death, the boys incurred a large debt on the ranch. Family friend Willard George paid it off in 1929 but allowed the Wilsons to continue to operate the ranch. (Courtesy of UNLV Libraries Special Collections.)

At the Spring Mountain Ranch, a spring-fed creek and grassy meadows offered a welcomed oasis for travelers using this alternate route of the Spanish Trail through Cottonwood Valley. (Courtesy of UNLV Libraries Special Collections.)

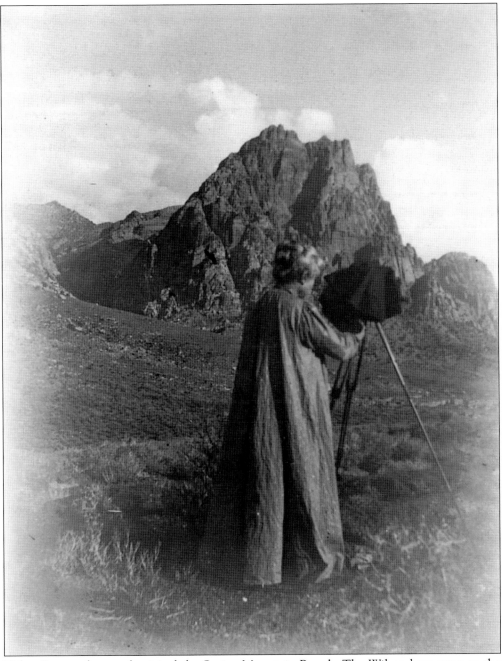

Helen Stewart frequently visited the Spring Mountain Ranch. The Wilson boys came to the Stewart Ranch to be tutored. (Courtesy of UNLV Libraries Special Collections.)

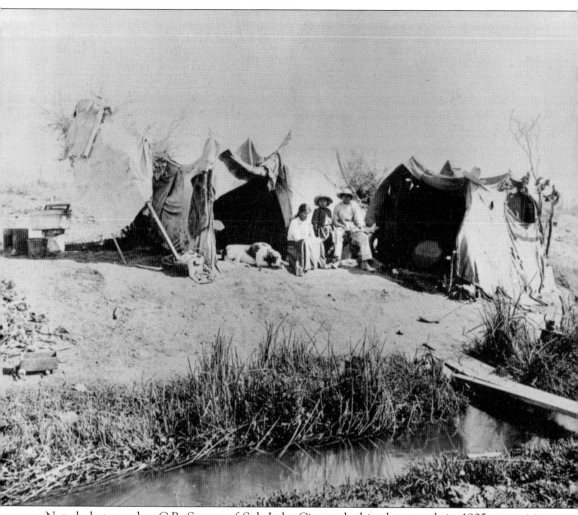

Noted photographer C.R. Savage of Salt Lake City took this photograph in 1905 on a visit to Las Vegas. He entitled it "Indian Paradise." However an article in the 1905 *Las Vegas Age* described a Mexican family encampment on the creek at this time. (Courtesy of UNLV Libraries Special Collections.)

In 700 AD, Paiutes moved into Southern Nevada, spending summers in the mountains and winters in the valley and Big Springs. They also killed game, including deer, rabbits and mountain sheep. Many grew corn, pumpkin and melons. Octavius Gass told the story that he left his property due to a threat of an Indian attack. Upon returning, he found Chief Tecopa protecting his property. In 1911 Las Vegas was chosen by the US government as one of eight sites to establish a Native American reservation. (Courtesy of UNLV Libraries Special Collections.)

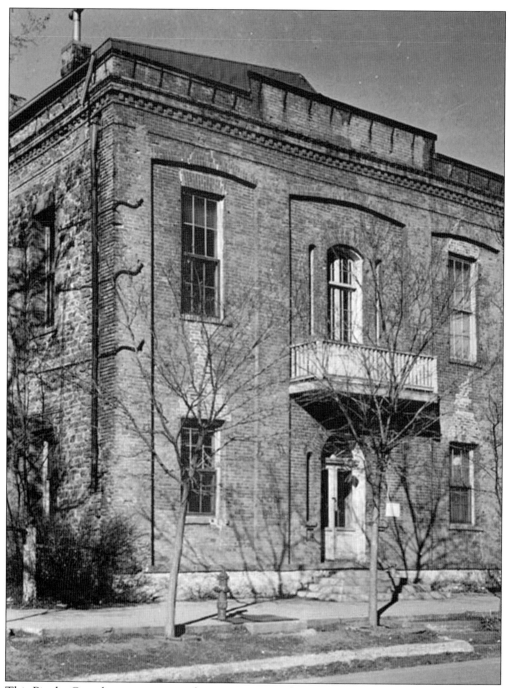

This Pioche Courthouse represents the justice system that was in place for early Las Vegas. The area was still a part of Lincoln County until 1909, when it split into Clark County. The courthouse was known as the Million Dollar courthouse due to fiscal mismanagement. The debt on the building cost nearly $1 million before it was paid off. The investigation into Archibald Stewart's murder also occurred here in 1884. (Courtesy of UNLV Libraries Special Collections.)

Three

THE RAILROAD ARRIVES AND THE NEW TOWN EMERGES

Rumors of the railroad circulated for years. No railroad crossed Southern Nevada in 1900. There were only 30 people at the Las Vegas ranch. Railroad rivals eyed the Las Vegas Valley as a point for shop facilities and a town because of its plentiful water supply and availability of timber in nearby mountains. In the mix was the Stewart Ranch, with over 1,800 acres of fenced land. The foundation for the modern-day Las Vegas was laid in 1902 when Helen Stewart sold her land to Sen. William A. Clark of the San Pedro, Los Angeles & Salt Lake Railroad.

Las Vegas was born in 1905 on the cusp of the golden age of railroads and the emerging era of the automobile. With the San Pedro, Los Angeles & Salt Lake Railroad, Clark spanned the Southwest with iron rails, shortening the travel time between Los Angeles and Salt Lake City by more than one day. He said, "I will leave no stone unturned." However, it was difficult to get to the state capitol at Carson City by either mode of transportation, and a direct rail link was completed in 1907.

As it offered a more direct line to Salt Lake City, Las Vegas was chosen. It also had plenty of underground water for steam engines, repair shops, and residences for workers. It became a modern boomtown due to the railroad. The railroad promised to build a water system, improve all the streets, and construct a depot and other buildings.

However, Las Vegas remained small during the peak of construction in 1905 because it lacked facilities for the 100-member construction crew. Eventually, Las Vegas became a modern boomtown.

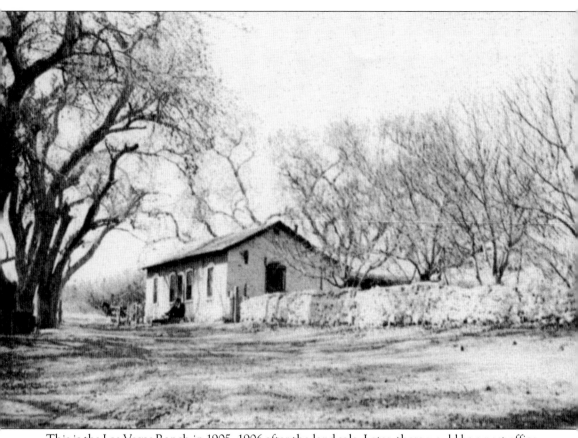

This is the Las Vegas Ranch in 1905–1906 after the land sale. Later, there would be a post office, meat market, store, and hotel where ham and other breakfast foods were available. Other owners raised dairy cattle and continued farming. (Courtesy of UNLV Libraries Special Collections.)

In 1889, railroad surveyors came. Senator Clark needed a line south from Salt Lake to Southern California along the Mormon Trail. He was a partner with the San Pedro, Los Angeles & Salt Lake Railroad. The absence of a route from Salt Lake City created a blank space in the network. Las Vegas filled that gap. (Courtesy of UNLV Libraries Special Collections.)

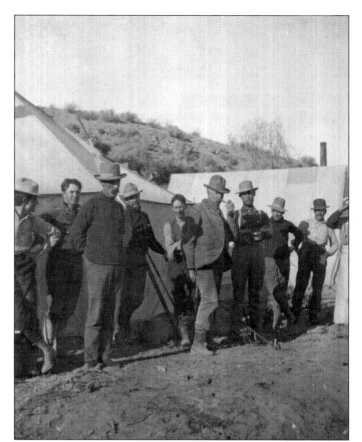

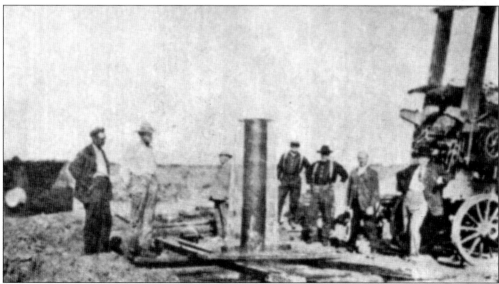

The abundance of artesian wells, such as this one, was one of the reasons that the railroad selected Las Vegas. Walter Bracken discovered this when he worked for the railroad and first came to Las Vegas with the survey party in 1902. By March 1905, railroad surveyors began driving stakes to mark the lots in the long awaited town site. (Courtesy of UNLV Libraries Special Collections.)

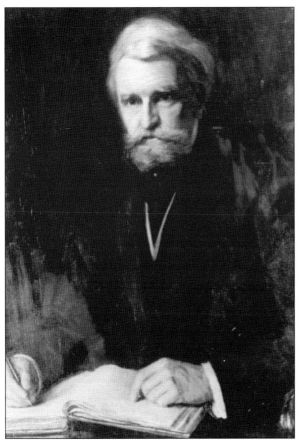

William A. Clark started out as a prospector in Montana in 1863. By the turn of the century, he had amassed a huge fortune in mining, smelting, and banking. He served as president, board director, and sole stockholder in 14 lucrative companies. William "Copper King" Clark was known for building great empires in the West. He married his young ward, Anna Eugenia La Capelle, and they had two children, Andree and Hugette. Hugette died in 2011 at the age of 104. Her billion-dollar estate is still a source of controversy. (Courtesy of UNLV Special Collections.)

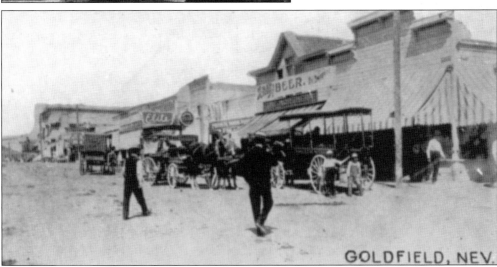

Events happened outside Las Vegas that affected the railroad town yet to be born. In 1902, two miners struck gold in Goldfield. This would be the largest mining rush in Nevada. It created the opportunity for a railroad link between Goldfield and Las Vegas and for farmers to furnish materials to the miners. It created great wealth for many and helped create the modern Nevada of tourism. (Courtesy of UNLV Libraries Special Collections.)

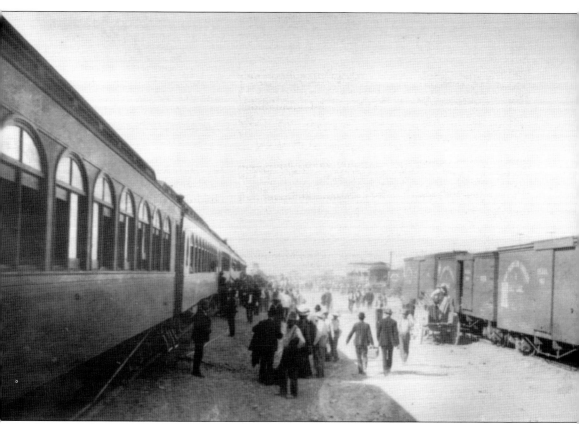

The Salt Lake-to-Los Angeles line was officially opened on May 1, 1905. Pictured is the first public train in Las Vegas from Los Angeles. Other excursion trains began arriving in April. In California, Clark negotiated a trackage rights agreement, allowing his new line to use the existing Atchison, Topeka & Santa Fe Railway routes over the Cajon Pass instead of constructing his own tracks across the pass. The railroad stimulated the area's economy and benefited investors. (Courtesy of UNLV Libraries Special Collections.)

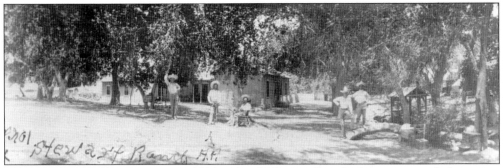

Pictured is a railroad survey party in 1904 at the old Stewart Ranch. Surveyors traveled in spring wagons and made camp near shaded trees, streams, and ponds. Once Senator Clark acquired the land, he was able to push construction south toward Las Vegas. With the completion of the railroad, the history of Southern Nevada entered the modern age. After building the rail line through the old Stewart Ranch, almost 900 acres were left for development. (Courtesy of UNLV Libraries Special Collections.)

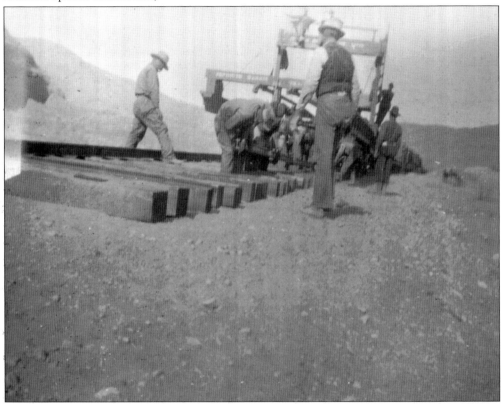

Clark's workforce began construction in Nevada along the existing Union Pacific grade. The railroad, which had completed its line connecting Southern California with Salt Lake City in January 1905, needed people to live at the southern end of Nevada to ice down Eastbound cargoes of fresh California produce, to water and feed the livestock, and to serve the trains. The railroad planned to build a town. As construction progressed, tent saloons, stores, and boardinghouses kept pace with the laying of the track. A tent settlement called Las Vegas sprang up a half mile west of the old Stewart Ranch. On October 20, 1904, steel rails reached the town. (Courtesy of UNLV Libraries Special Collections.)

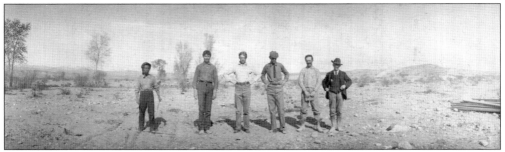

This is a railroad camp in Southern Nevada in 1903–1904. The Las Vegas Land and Water Company was created by the railroad to develop the town and distribute water. By January 1905, materials arrived by the carload to build dwellings, an ice plant, roundhouses, and shops. About 150 buildings were either completed or under construction by January 30, 1906. (Courtesy of UNLV Libraries Special Collections.)

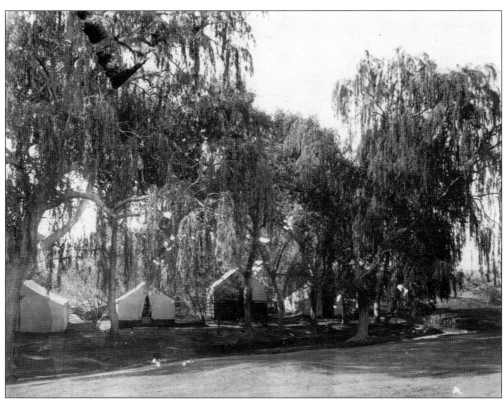

Pictured here are tents on the old Stewart Ranch. The tents were home to individuals who came to the land sale and remained their homes for many months in the dusty desert. The temperature was unseasonably hot on the day of the auction. (Courtesy of UNLV Libraries Special Collections.)

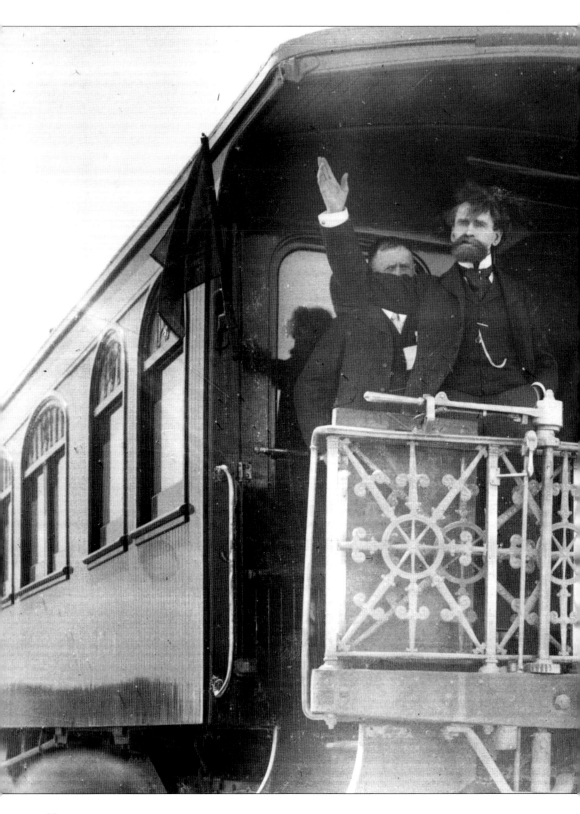

This train was named "Mr. Clark's Special" when it arrived on April 23, 1905. Montana senator William A. Clark's dream of connecting the tidewater area of Southern California with the inland empire built by Brigham Young in Utah was becoming a reality. The San Pedro, Los Angeles & Salt Lake Railroad was to be the link. A new town, Las Vegas, was about to be launched in the desert sands of Southern Nevada. It was selected for its abundant water. (Courtesy of UNLV Libraries Special Collections.)

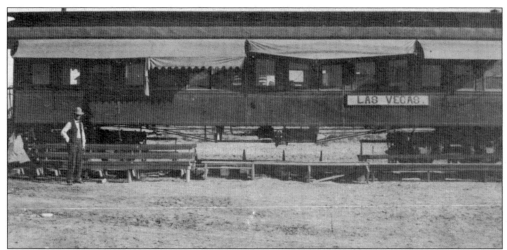

The first railroad station in 1905 was an old railroad coach placed along the track around January 1905. The coach housed the Las Vegas depot and ticket office, as well as desks for the Western Union Telegraph and Pacific Express Fruit Company. Later that summer, more permanent buildings replaced these primitive facilities. (Courtesy of UNLV Libraries Special Collections.)

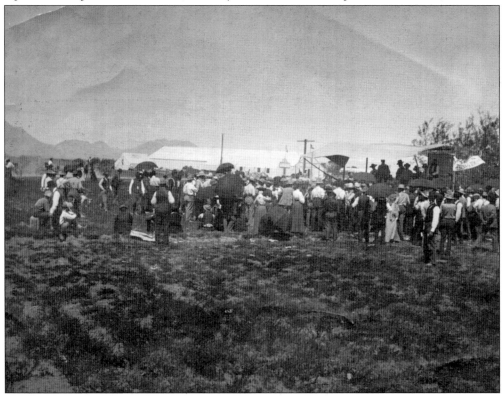

Overwhelmed with applications, the Board of Directors of the railroad decided that the town lots would be sold at auction on May 15,1905. Clark began an aggressive campaign to lure prospective buyers to the area. There were 2,000 people present the first day. Purchasing the first early Las Vegas lots were the Griffiths and Von Tobels. E.W. Griffith purchased two lots. Father and son moved to Las Vegas a month later. (Courtesy of UNLV Libraries Special Collections.)

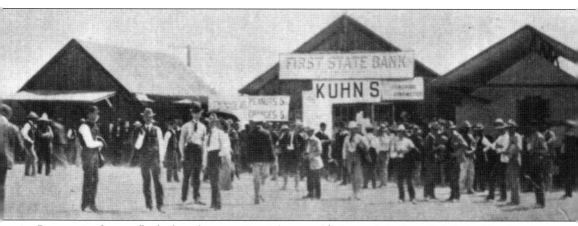

Prospective buyers flocked to the area. Special rates of $16 roundtrip from Salt Lake City lured people to the site, as prospective buyers flocked to the area. Las Vegas might never have been known if it had not been for Clark's decree to build a railroad through this remote region. (Courtesy of UNLV Libraries Special Collections.)

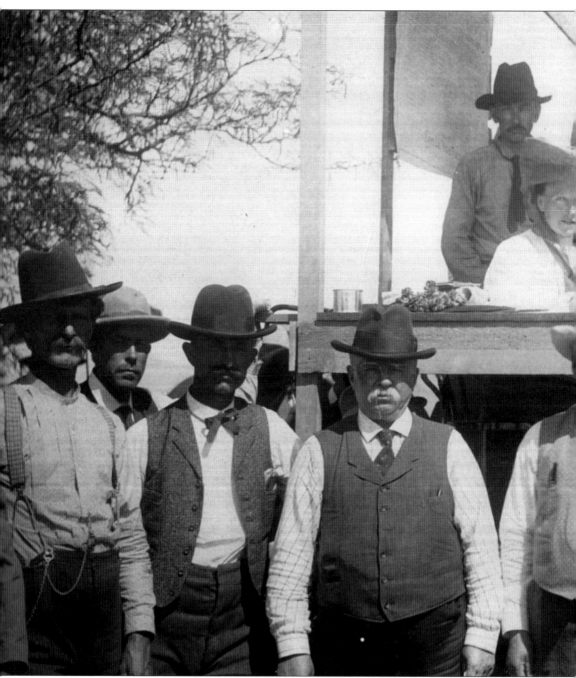

This is the auction of Clark's town site lots in Las Vegas on May 15–16, 1905. Five days before the sale, 3,000 applications had been filed with the Los Angeles agent through John Park. Since the applications exceeded the lots, an auction was to take place, and the contracts were canceled. Beneath a mesquite tree on what is now North Main Street stood a crude lumber platform, which was where an auctioneer and railroad officials could sit in the shade. The temperature was 110, which was hot for May. People sweating in the heat stayed as the auctioneer gaveled out the future of Las Vegas. The spirited bidding boosted the prices up to four times their original

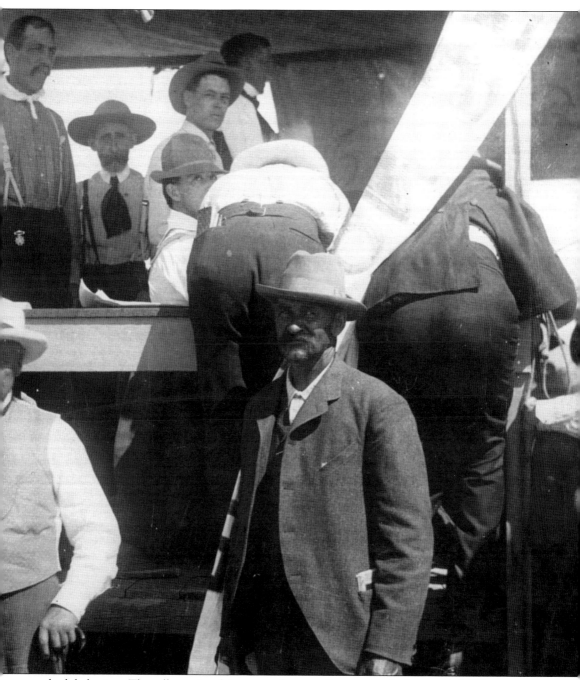

scheduled prices. The tall man in white suspenders standing on the platform is C.O. Whittemore, attorney for Salt Lake Railroad. The short man on his left, with broad-brim hat and wearing a black necktie, is Frank A. Waters, roadmaster of Salt Lake Railroad. The man with a mustache standing on the ground to the right is Charles Towner, the original owner of Indian Springs ranch. The heavyset man with white mustache standing on the ground is Mark Weight, mayor of Pasadena, California. (Courtesy of UNLV Libraries Special Collections.)

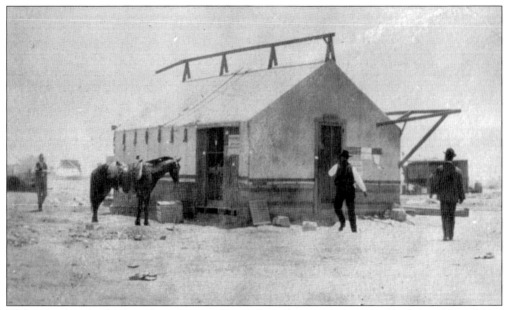

Walter Bracken (with white sleeves) is seen here in his role as postmaster, in Block 3 on South Main Street. Bracken's pony Ben is standing at the doorway. He established a new post office in a tent at the old ranch and made it his headquarters. (Courtesy of UNLV Libraries Special Collections.)

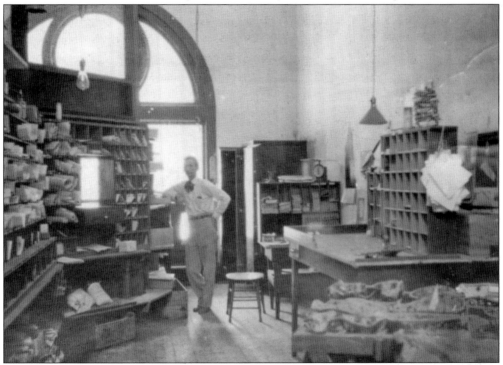

This is the Las Vegas Post Office in 1908. The first post office opened on the Las Vegas Ranch in December 1893. Walter Bracken was the first postmaster of the 20th century for Las Vegas in 1904. By 1907, letters were picked up by Las Vegans in more spacious quarters on Fremont Street in the First State Bank Building. (Courtesy of UNLV Libraries Special Collections.)

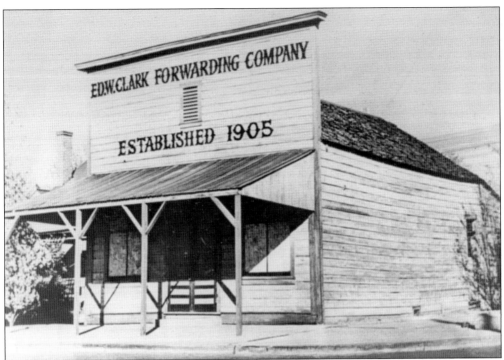

This is the Ed W. Clark Forwarding Company in 1905. It belonged to one of the first settlers in Las Vegas. By 1905, Clark Forwarding Company was headquartered in the new town built by the railroad. They were hauling freight into mining camps, such as Beatty and Rhyolite to the north and El Dorado Canyon to the south. In later years, Clark wielded power among Nevada Democrats who controlled the legislature and governor's mansion. (Courtesy of UNLV Libraries Special Collections.)

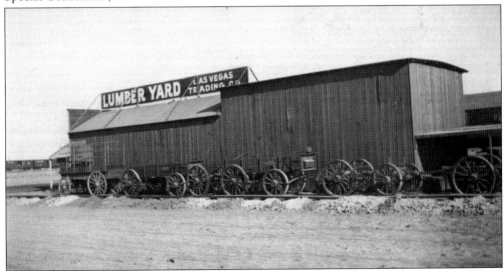

This is one of the lumberyards started in early Las Vegas. By the time Las Vegas was a month old, its people had erected nearly every kind of establishment. Sounds of hammers and saws could be heard around the clock. Several sturdy buildings were finished with lumber provided by these early lumberyards. (Courtesy of UNLV Libraries Special Collections.)

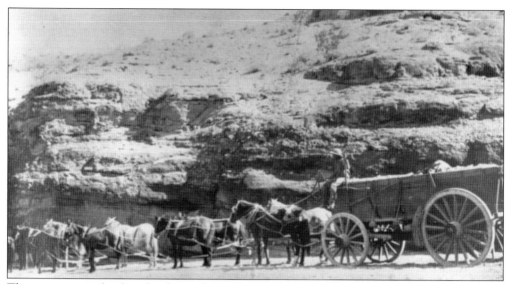

These wagons are hauling freight to El Dorado Canyon. Ranchers and local businessmen in Las Vegas traded with miners in El Dorado Canyon. George Hearst had the Wall Street Mine there. Longtime miners felt that the rich veins in Arizona were a continuation of the veins running through Techatticup in Nevada. (Courtesy of UNLV Libraries Special Collections.)

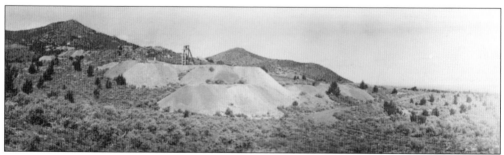

These are mines in nearby Pioche. Mining continued to be one of the major businesses in Las Vegas. The railroads also brought ore from them. Mule freight wagons carried supplies from the train to the Bullfrog Mining District, which was 120 miles to the northwest. (Courtesy of UNLV Libraries Special Collections.)

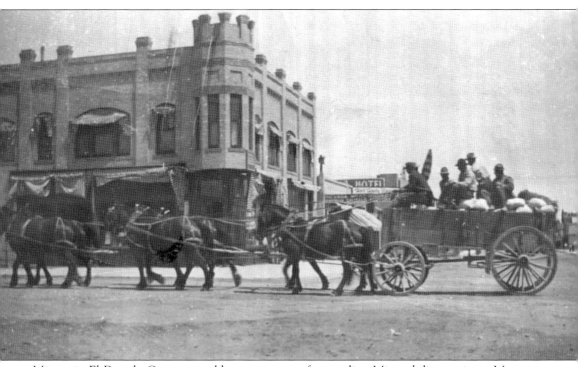

Miners in El Dorado Canyon would come to town for supplies. Mineral discoveries at Mount Potosi and El Dorado Canyon brought renewed activity to Las Vegas. Mining camps created a need for fresh produce. Several small farms were located in the Las Vegas Valley that helped with the supply. (Courtesy of UNLV Libraries Special Collections.)

This is the Las Vegas Creek. John T. McWilliams succeeded in alerting the town to the danger of the cesspool overflowing into Las Vegas Creek. By 1916, the water supply was unsanitary. They found a new filtering system for water flowing into the reservoir. (Courtesy of UNLV Libraries Special Collections.)

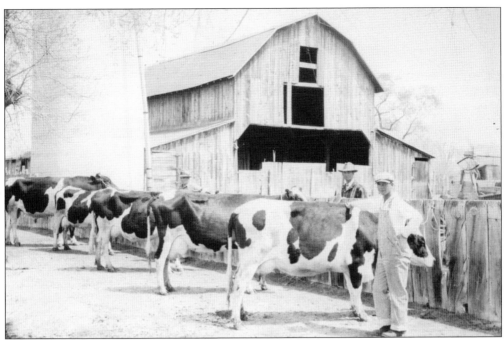

This is the Anderson Dairy farm around 1910 near West Charleston, where University Medical Center is today. In 1907, Harry Anderson selected a sparsely vegetated piece of land just east of one of the valley's artesian wells where he raised Holstein cattle. He grazed the south side of the road. As Las Vegas grew, more people needed goods and services that the dairy provided. The modern Anderson dairy is descended from this business. (Courtesy of Anderson Dairy.)

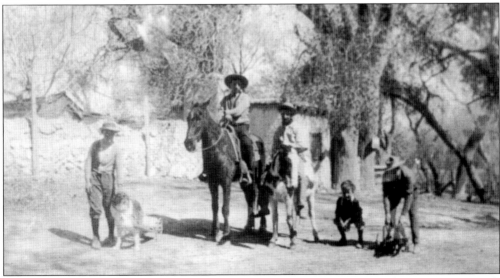

These people are on the old Stewart Ranch in 1909. The population stood at 1,500 in 1909. A series of storms set into motion flash floods that wiped out 100 miles of track in Meadow Valley Wash northeast of Las Vegas and cut service to Los Angeles. Essentially marooned during the long reconstruction of the rail lines, Las Vegans began to realize their dependence on the railroad. Layoffs created a slump in the local economy. The population dwindled to under 1,000. (Courtesy of UNLV Libraries Special Collections.)

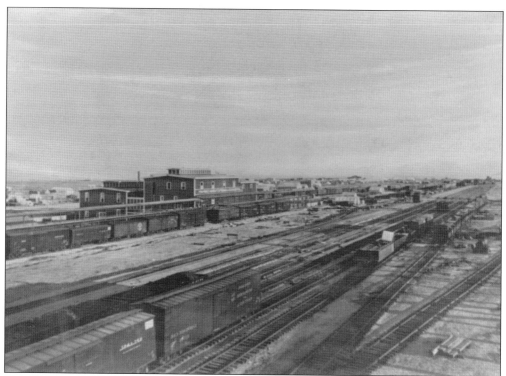

Senator Clark was trying to build a railroad to the boomtowns of Tonopah and Goldfield. He put his brother in charge and completed construction to Beatty, Rhyolite, and Goldfield but never to Tonopah. Then, it was necessary to establish shops and other necessities for the miners and other operators of the road. (Courtesy of UNLV Libraries Special Collections.)

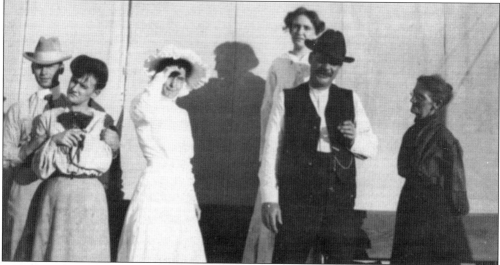

Here are waitresses who were brought in from Los Angeles to work at the tent hotel. To handle the crowd, Charles "Pop" Squires and partners erected a tent, 130 feet long by 40 feet wide. After the frenzy of the auction died down, many of the investors became impatient with the slow growth. A month and a half after the auction, two dozen of the investors had abandoned their lots. (Courtesy of UNLV Libraries Special Collections.)

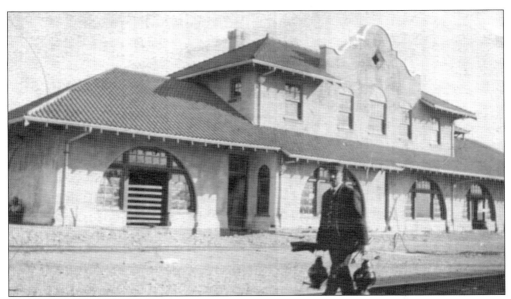

The first permanent railroad station in 1905 of the San Pedro, Los Angles & Salt Lake Railroad in Las Vegas was located at the head of Fremont Street. It was the center of economic and social life. An afternoon lunch at the dining room—fondly called the "beanery"—and a look at the arriving passengers were common occurrences. The San Pedro, Los Angeles & Salt Lake Railroad was known for its depot buildings, many of which were imposing structures in the Mission Revival style. (Courtesy of UNLV Libraries Special Collections.)

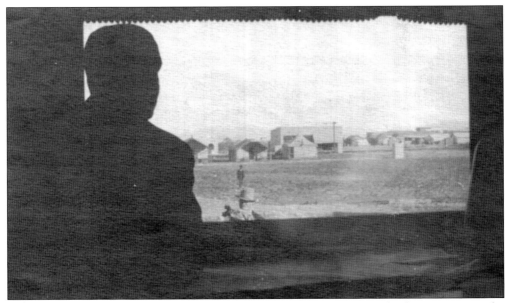

Here, in July 1905, the photographer is looking through the windows of a dining car near the railroad station. The principal method of travel was by train, and this was one of the first ones through. (Courtesy of UNLV Libraries Special Collections.)

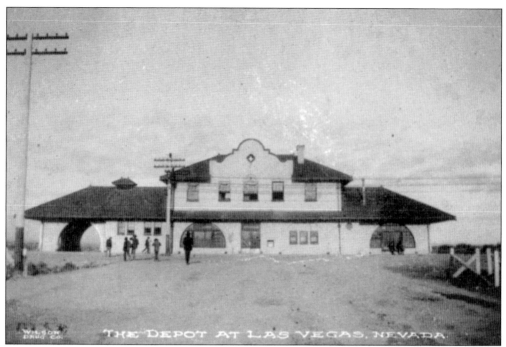

The depot was similar in architecture to the depot in Caliente. With the passenger depot on Main Street and tracks parallel to it, streets provided a key business district. (Courtesy of UNLV Libraries Special Collections.)

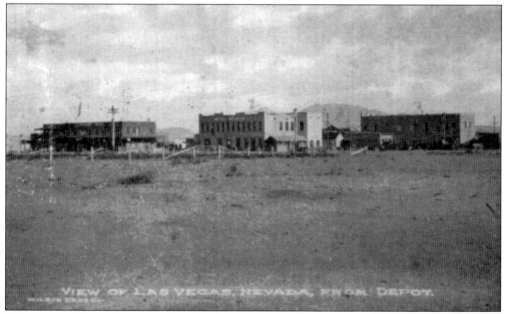

This postcard shows the view of Las Vegas from the depot. The town was progressing slowly. By 1910, fewer than 1,000 people lived in the town and its environs. Clark sold his interest in the railroad in 1921 to the Union Pacific. They fired workers, and the union called for a strike on November 25, 1921. The Las Vegas workers did not strike until July 21, 1922. (Courtesy of UNLV Libraries Special Collections.)

Four

Civilization Comes to Las Vegas

In the early 1900s, people began arriving in dusty Las Vegas. The men were attracted by rumors of a growing city where a good livelihood could be made by working on the new railroad or mining operations or providing services to the new citizens. With them came wives and children to help shape new lives for their families. They possessed diverse backgrounds and levels of education. But most were young and ambitious with a determination to build a new life.

In 1902, Helen J. Stewart sold her land to Senator Clark of the San Pedro, Los Angeles & Salt Lake Railroad, setting the stage for the establishment of the city of Las Vegas. She became a civic fixture in the town she helped found. The women of the Mesquite Club brought civilization to this "isolated place" by planting trees, serving on school boards, building libraries, and bringing opera to the new town. Their husbands were busy with their banks, hotels, and lumberyards.

Helen J. Stewart was a friend to the Southern Paiutes. She collected their baskets and admired their artistry. The Southern Paiutes would also get a reservation from 10 acres of land deeded by her.

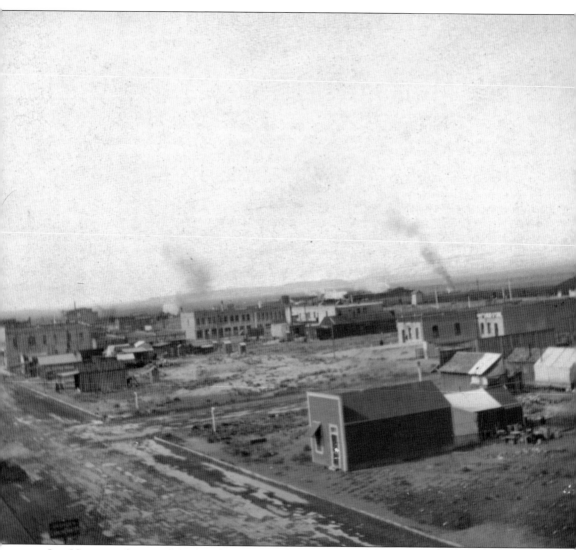

Las Vegas was born in May 1905. But it was not until December that wiring of the town for electricity was even begun. In February 1906, the power plant at the railroad icehouse began operation and residents could turn on their electric lights for the first time. (Courtesy of UNLV Libraries Special Collections.)

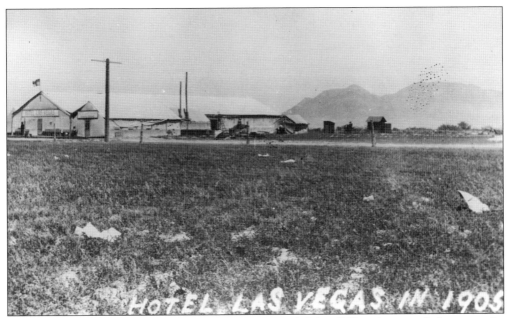

The tent Hotel Las Vegas was under construction in early May 1905 and was ready for guests the day before the auction. C.P. Squires managed it. All canvas and lumber used in the building were cut to size and hole-bored in Los Angeles, ready to be bolted together on arrival in Las Vegas. (Courtesy of UNLV Libraries Special Collections.)

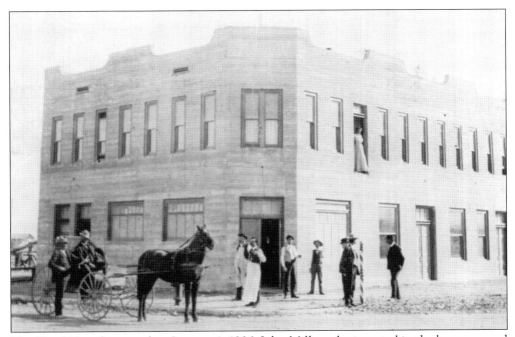

The Hotel Nevada opened on January 1, 1906. John Miller, who is seated in the buggy, owned it. His future wife Rose is pictured in the second-story opening. The rooms had electric lighting and steam radiators. The Elks formed a lodge there that year. (Courtesy of UNLV Libraries Special Collections.)

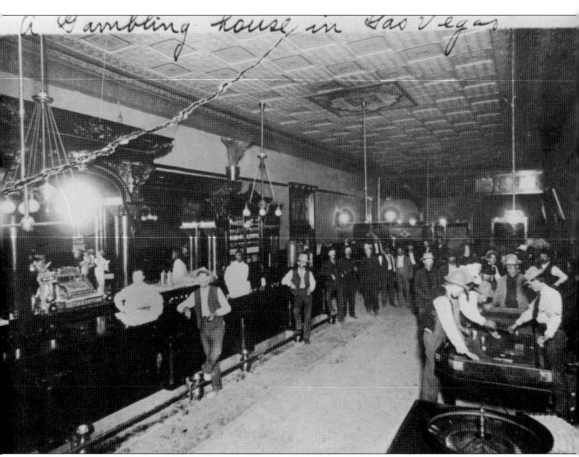

A Gambling House in Las Vegas

The Arizona Club in 1906 was the most renowned and luxurious club, with beveled glass and a bar and marble baseboards. It boasted a drink called "slow gin fizz." It was located in Block 16, which was bounded by Ogden, Stewart, First, and Second Streets. That area was allowed unrestricted gambling and prostitution. Temperance-minded railroad officials inserted a special clause into the deed of sale for lots in each of the 40 square blocks—a clause forbidding the sale of liquor except in Block 16 and 17. The deeds did allow hotels and rooming houses to sell alcohol. (Courtesy of UNLV Libraries Special Collections.)

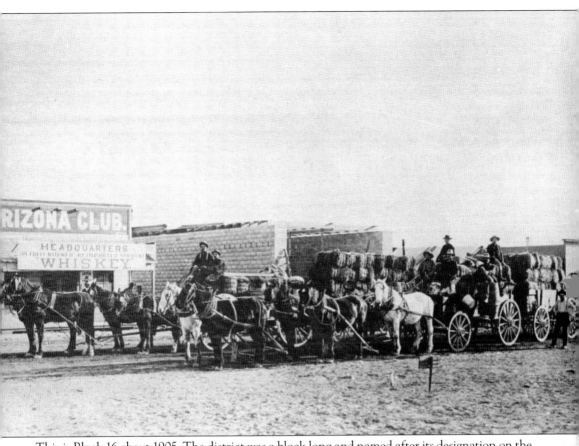

This is Block 16 about 1905. The district was a block long and named after its designation on the town map. During the early days of Las Vegas, entertainment consisted chiefly of liquor and the women of Block 16. While drinking strong whiskey and telling stories, railroad men, prospectors, and miners crowded around scattered tables playing cards. A few women in gaudy satins danced with men and induced them to drink to increase their commissions on the liquor sales. Many saloons had rooms upstairs or in back that they rented to prostitutes. Clubs had bands, and the girls danced with the customers for $1 a dance. (Courtesy of UNLV Libraries Special Collections.)

This is a camp on Las Vegas Creek. This was the creek that brought people to Las Vegas in the early days. Unfortunately, the railroad brought pollution, and the creek eventually dried up. (Courtesy of UNLV Libraries Special Collections.)

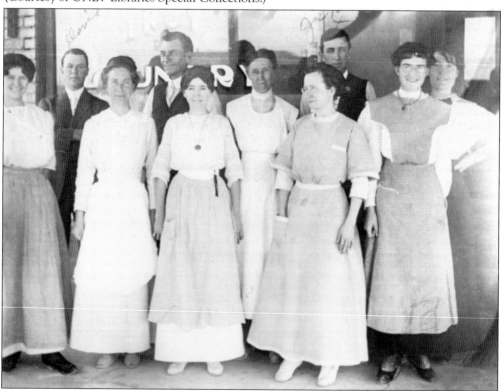

This is a laundry in downtown Las Vegas about 1916. Constant dust storms were the cause of continuous house cleaning. Hanging out clothes on an outdoor line was simply a lost cause. This laundry was a welcome addition to the new town. (Courtesy of UNLV Libraries Special Collections.)

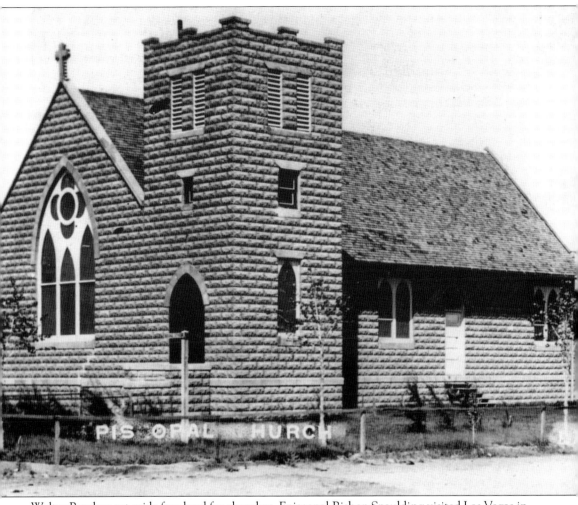

Walter Bracken set aside free land for churches. Episcopal Bishop Spaulding visited Las Vegas in 1905 and looked for lots for the church. Rector Gray asked the Ladies Guild to give a name to the church. They met at the Squires home on January 11, 1908. A debate was held but the majority decided on Christ Church. First services were held in September 1907. This is the church in 1910. (Courtesy of Nevada State Museum Las Vegas.)

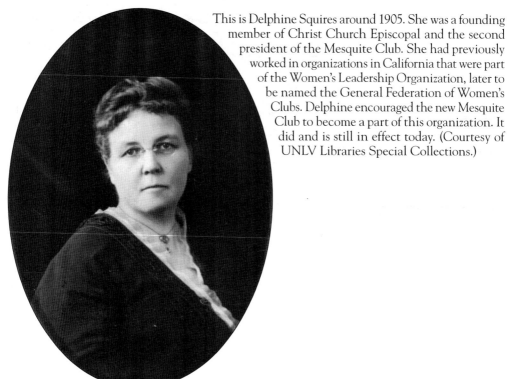

This is Delphine Squires around 1905. She was a founding member of Christ Church Episcopal and the second president of the Mesquite Club. She had previously worked in organizations in California that were part of the Women's Leadership Organization, later to be named the General Federation of Women's Clubs. Delphine encouraged the new Mesquite Club to become a part of this organization. It did and is still in effect today. (Courtesy of UNLV Libraries Special Collections.)

The sagebrush desert quickly gave way to new homes. This is Delphine Squires in front of her house in 1906. It was completed in June. It was at 411 East Fremont Street between Fourth and Fifth Streets. A permanent home made of wood, adobe, or cement block was a sign of achievement or prosperity. This was the elite area from 1905 to 1910. They later moved to 714 South Seventh Street. (Courtesy of UNLV Libraries Special Collections.)

Here, a family is having a picnic on the Las Vegas Creek on the old Stewart Ranch site. Even after the ranch was sold, the area became a focal point for many family gatherings. (Courtesy of UNLV Libraries Special Collections.)

This is Pop Squires (far right) in later years as a member of the Rotary International. In 1903, Charles Squires heard about the plans of Sen. William A. Clark to extend his San Pedro & Los Angeles Railroad all the way to Salt Lake City. He borrowed $25,000 to establish a bank, hotel, lumberyard, and real estate firm. Each of Squires's partners put up $1,250 to develop what became known as the First State Bank. (Courtesy of UNLV Libraries Special Collections.)

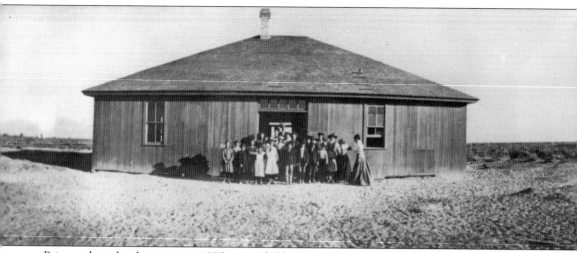

Prior to this school opening in 1905, some children were sent to Los Angeles, where they boarded with relatives or host families. This simple two room wood frame building served well for five years. A belfry was added in 1910 just before the building burned to the ground in October. Classes met for a time at the Methodist church until the next school opened on 4th Street. It would be a few years before a better school was built and a school board elected. (Courtesy of UNLV Libraries Special Collections.)

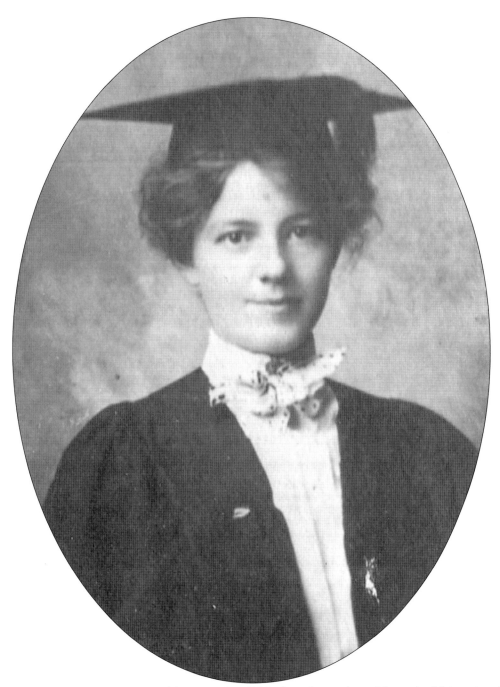

Mabel Grant Plumb is pictured here in May 1904 when she graduated from the University of Nevada. She was one of the first schoolteachers. In fall 1905, schoolchildren got a reprieve, as there was no schoolhouse. The primitive tent structure by Las Vegas Creek used as a school in the spring had been converted to a courthouse. In mid-summer, the school fund contained $25.10. In mid-September, the school board purchased the Old Salt Lake Hotel for $150 and moved it out in the middle of nowhere at Second and Lewis Streets. School opened at last on October 2 with 64 students and two teachers. (Courtesy of UNLV Libraries Special Collections.)

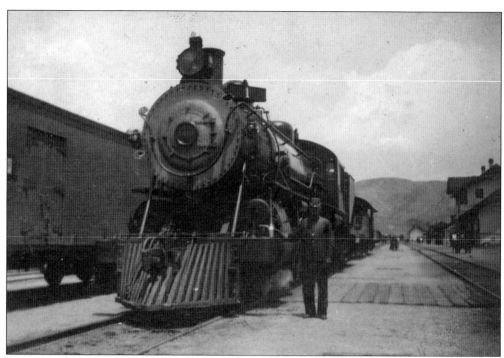

Las Vegas was very much a railroad town. When there were problems with the railroad, the town suffered. (Courtesy of UNLV Libraries Special Collections.)

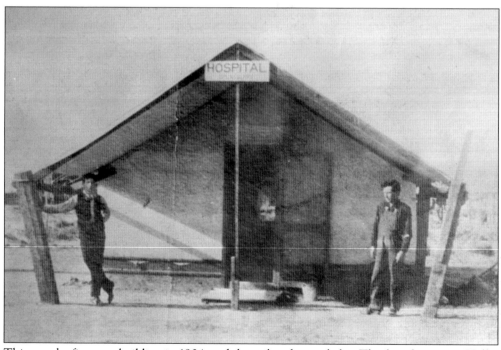

This was the first tent building in 1904, and the railroad provided it. The first doctor was Hallie Hewetson, son of an Ohio doctor and surgeon who taught at an Omaha Medical School. (Courtesy of UNLV Libraries Special Collections.)

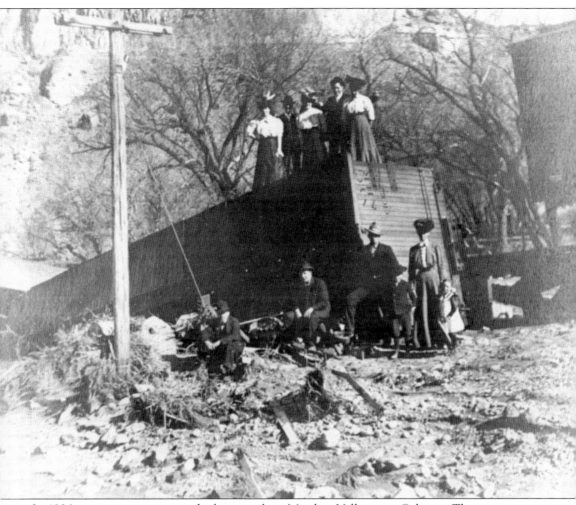

In 1906, springtime storms washed out track in Meadow Valley near Caliente. The next year, there was another. Track problems affected Las Vegas's growth. The great mining boom in Southern Nevada which brought the railroad and freight business to Las Vegas could soon be over and financial panic and collapse was around the corner. (Courtesy of UNLV Libraries Special Collections.)

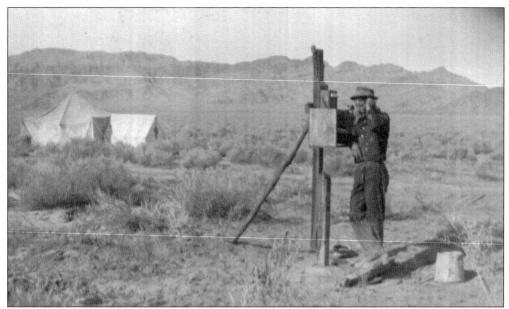

This was one of the first phones in Las Vegas around 1906. At first, the joint electric-telephone company did not hire anyone to handle phone calls past 8:00 pm. When the Consolidated Power and Telephone Company passed out telephone numbers, they assigned the number "1" to the First State Bank for Pop Squires. Long-distance telephone service was yet to come. (Courtesy of UNLV Libraries Special Collections.)

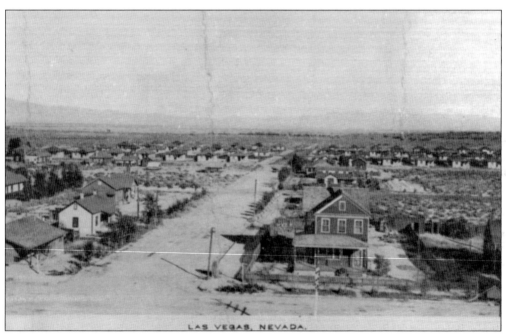

This is Main Street looking east with railroad houses in the background. In 1909, the railroad expanded local yards and built new repair shops. Workers built 64 concrete-block cottages downtown for employee families. The construction from 1909 to 1911 responded to the housing crunch for employees. (Courtesy of UNLV Libraries Special Collections.)

Denver S. Dickerson was the acting governor when the split from Lincoln County into Clark County occurred. This was the most important political issue. July 1, 1909, was a daylong celebration complete with baseball games between Las Vegas and Good Springs, burro and wheelbarrow races, a band concert, and a ball at the opera house. Dickerson was also the first governor in the new governor's mansion in 1909. (Courtesy of UNLV Libraries Special Collections.)

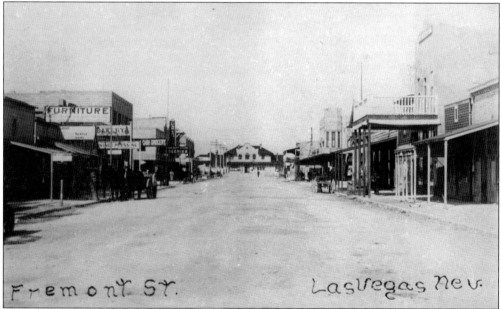

This is Fremont Street from Second Street looking west in 1910. All blocks were 300 by 400 feet. The streets were 80 feet wide. The alleys were 20 feet wide. All lots were 25 feet wide by 14 feet deep. The commercial area was half a block on the north and south sides of Fremont Street. It was hoped that Fremont Street would grow with lots of businesses, but in the early years, there were more vacant lots and dust than businesses. (Courtesy of UNLV Libraries Special Collections.)

On March 17, 1911, Gov. Tasker Oddie (on the far left) approved the city charter. City incorporation gave rise to formalized local politics. It established a mayor and four commissioners; Peter Buol was the mayor. The commissioners were W.J. Stewart, Ed Von Tobel, C.M. McGaven, and J.J. Coughlin. Buol was a mayor for only two years but remained a prominent figure in the city's development. This was the time of the Progressive Era in national politics, but Las Vegas was less progressive. (Courtesy of UNLV Libraries Special Collections.)

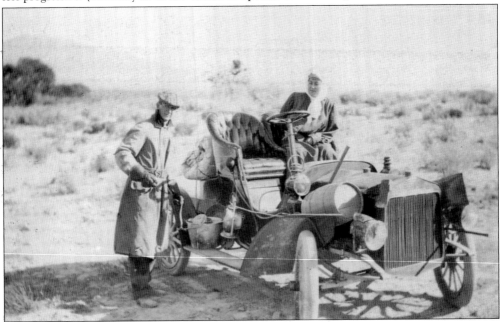

Walter and Anna Bracken are pictured in 1908 in their automobile. In those days, automobiles used to overheat, and it was necessary to stop to cool the engine. Roads that had been simple trails started to improve. A highway to Goodsprings enabled Las Vegas to take advantage of the zinc and lead mines. In 1914, a federal highway connected Southern California with Salt Lake City and other points east. (Courtesy of UNLV Libraries Special Collections.)

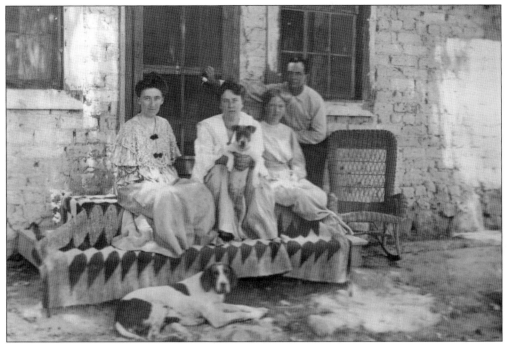

Walter Bracken lived with his wife and family at a gray stone house at 410 Fremont Street. They had a fashionable parlor and a collection of Paiute baskets. Pop Squires lived nearby at Fourth and Fremont Streets. (Courtesy of UNLV Libraries Special Collections.)

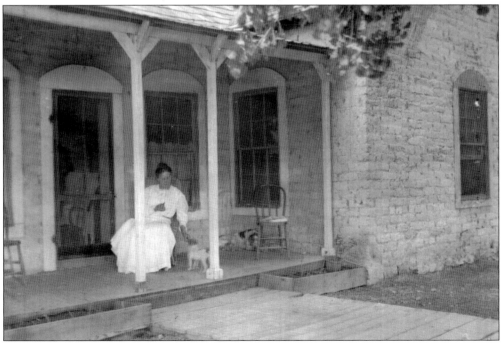

Anna Bracken is seated on her porch. There was intense heat during the long summer months. She was very active in numerous clubs and civic affairs and hosted gatherings at her home. (Courtesy of UNLV Libraries Special Collections.)

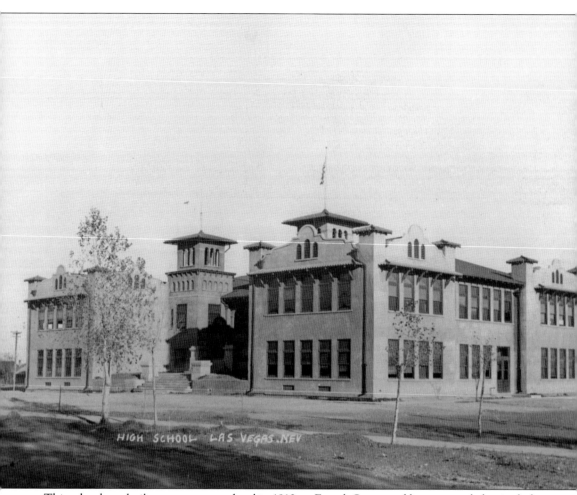

This school was built as a grammar school in 1910 on Fourth Street and later expanded to include high school students. In the fall of 1911 there were 111 elementary students and 17 high school students. The $35,000 combined grammar and high school was built on land donated by the railroad. Many believed that there were not enough children to fill it. Classes were dismissed in May due to the heat. The simple two-room wood frame building served well for five years. A belfry was added in 1910 just before the building burned to the ground in October. Classes met for a time at the Methodist church, but a new grammar school on Fourth Street was almost ready for occupation and would stand for many years. (Courtesy of UNLV Libraries Special Collections.)

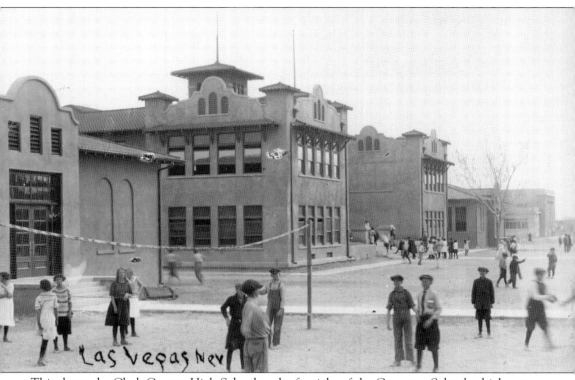

This shows the Clark County High School at the far right of the Grammar School, which was completed in 1917 for a cost of $50,000. Helen J. Stewart served on the school board at the time it was built. (Courtesy of UNLV Libraries Special Collections.)

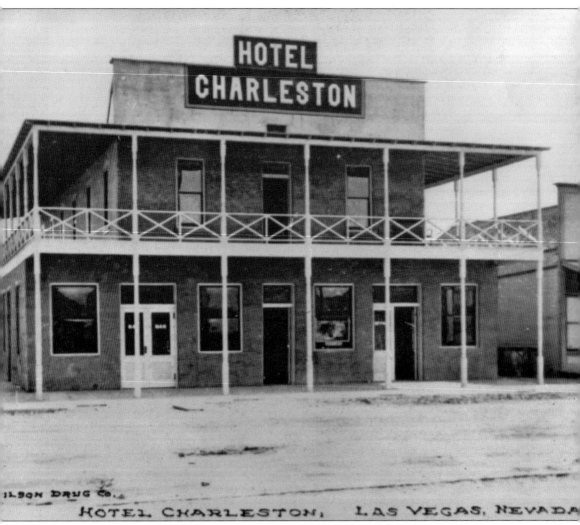

This is the Hotel Charleston in early Las Vegas. It was not located on the mountain where many families escaped the Las Vegas heat. (Courtesy of UNLV Libraries Special Collections.)

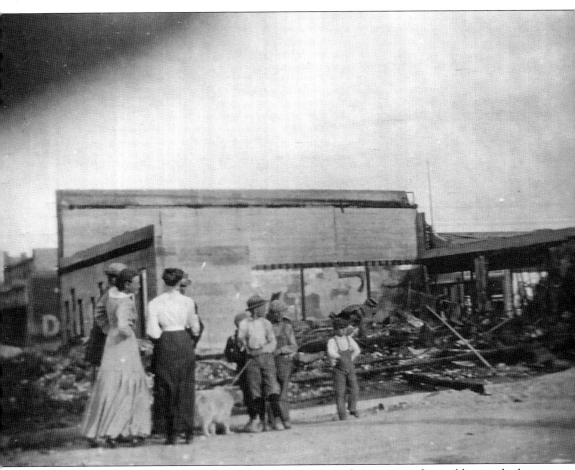

Despite the early creation of a volunteer fire department, fires remained a problem with the wooden town site. The most serious fire occurred on May 24, 1911. The Overland hotel burned one week before the city was incorporated. There was one death as well as several injuries. The citizens believed that incorporation would improve services. (Courtesy of UNLV Libraries Special Collections.)

This is the Lucky Strike Mine. With an improved road system, many townspeople would go prospecting. Much of the travel to the new mining camps came by way of Las Vegas. The city enjoyed the large trade for the local businesses. Mineral wealth added considerably to the business of the city. (Courtesy of UNLV Libraries Special Collections.)

This is the Ed Von Tobel Sr. home, owner of the Von Tobel lumberyard opened in early Las Vegas. He lost the 1910 election for county treasurer to Ed Clark. Ed Sr. was on the first city council. His son George became the first Republican in the Nevada assembly for Clark County. He served four years. (Courtesy of UNLV Libraries Special Collections.)

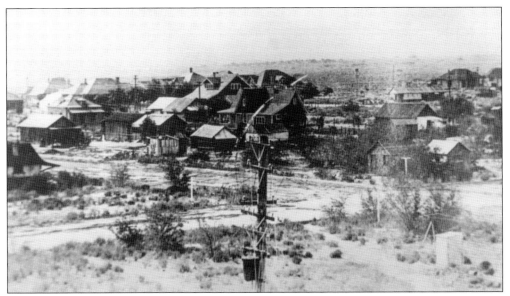

This is a 1908 panoramic view of Las Vegas. One can see how Las Vegas had already changed since the early days. (Courtesy of UNLV Libraries Special Collections.)

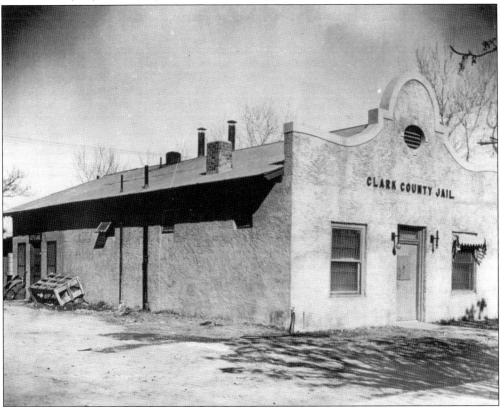

In July 1909, when the Clark County Commission held its first meeting, there was no jail in its temporary courthouse. Lincoln County agreed to accept prisoners from Clark County for $1.25 a day. (Courtesy of UNLV Libraries Special Collections.)

Block 20 at Third and Carson Streets was saved for the courthouse. It cost $50,000 and was dedicated December 7, 1914. It had marble hallways and granite steps. The city of Las Vegas used half of it for city hall. The Mesquite Club used part of it for a library. Without the Mesquite Club, there would not have been a library. After 14 years of nurturing work by the Mesquite Club, the City of Las Vegas took over the library as its own. (Courtesy of UNLV Libraries Special Collections.)

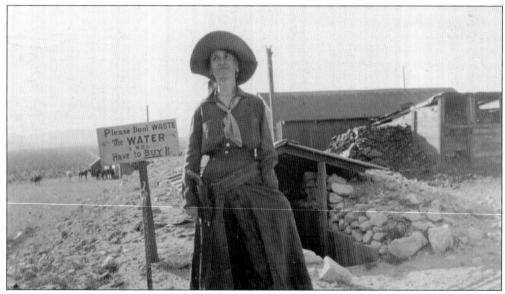

This is entrepreneur Bessie Rockwell who sold water to the miners. Her sign says, "Please don't waste the water. We have to buy it." That problem continues today. Las Vegas and its surrounding communities remained rough-and-tumble Western towns from 1905 to 1910, as one can tell from her gun. (Courtesy of UNLV Libraries Special Collections.)

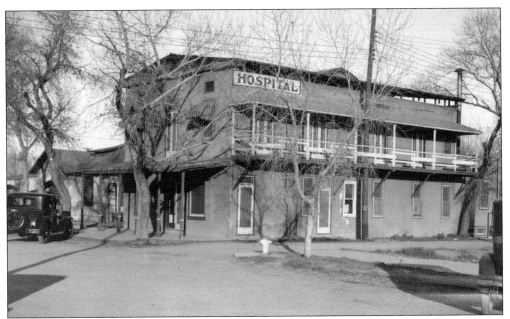

Dr. Roy Martin doubled the number of doctors in town when he arrived in August 1905. He raised the standard for medical care by converting the two-story Palace Hotel into a hospital. In 1918, the flu pandemic hit the town hard, but not as hard as neighboring towns. During summer months, Dr. Martin scheduled only essential surgeries and then only at the crack of dawn when the temperature was the coolest. (Courtesy of UNLV Libraries Special Collections.)

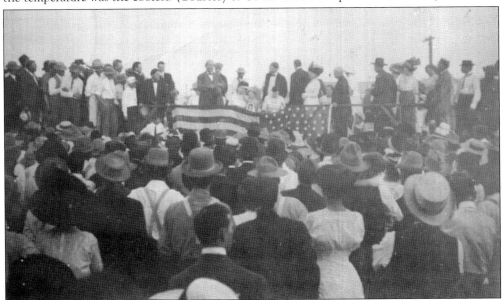

This was Secretary of State William Jennings Bryan (bald man in the middle) in Las Vegas in 1914 with Harley Harmon Sr. and Harley Harmon Jr. Bryan was a leading American politician who was a dominant force in the liberal wing of the Democratic Party. He was a three-time candidate for president, served as a representative from Nebraska in Congress, and was the 41st secretary of state. Before he held any political office, he went on the Chautauqua circuit, traveling from town to town giving paid speeches. (Courtesy of UNLV Libraries Special Collections.)

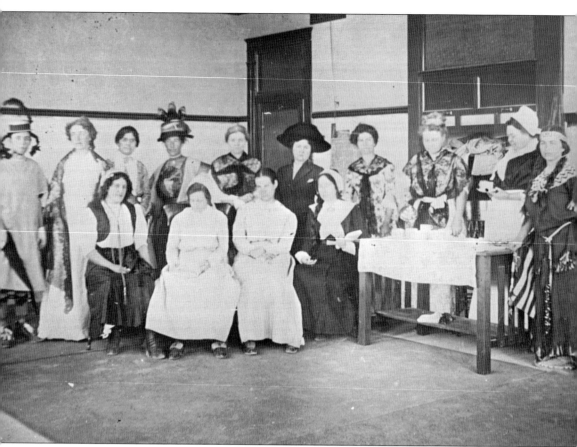

The women of the Mesquite Club are pictured in activities representing the founders. The Mesquite Club was founded in 1911 at Mrs. O.J. Enking's house. There were only 17 women in attendance. The first year was successful with twelve meetings and seven social functions. They celebrated with a joyous party that included school board members, city commissioners, and the president of the only bank in town. For the first few months, the new club met at members' homes and later moved to the opera house on Fremont Street. (Courtesy of UNLV Libraries Special Collections.)

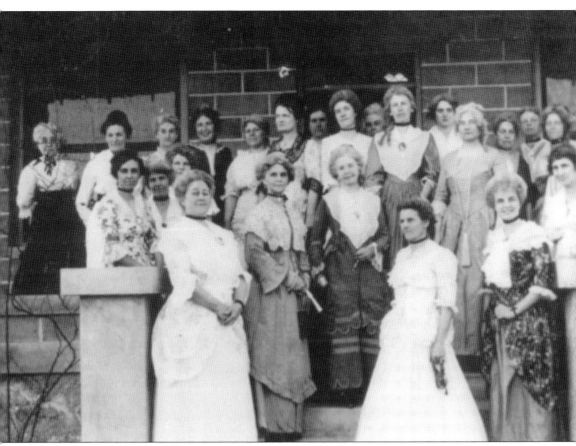

The Mesquite Club, the women's service organization, made a library campaign one of its priorities. They also opened a lunchroom on the screened porch of the chamber of commerce. President Esther Givens became the first Las Vegas resident to write a Nevada senator when the club petitioned the state leader for library funds. The women of the Mesquite Club were instrumental in fostering art, literature, music, fashion, and horticulture in Las Vegas. (Courtesy of UNLV Libraries Special Collections.)

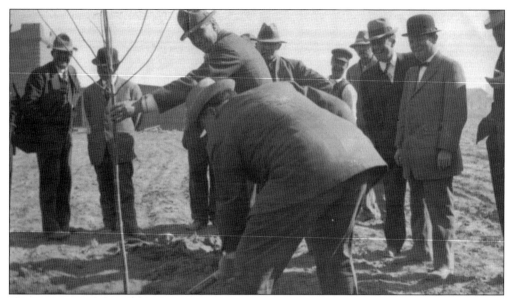

The Mesquite Club embarked upon a campaign with the slogan "To plant a tree is to bless the earth." They organized the first public tree-planting project in Las Vegas, raising enough money to purchase 2,000 cottonwood saplings. Here, C.P Squires is planting a tree in the Courthouse Park. (Courtesy of UNLV Libraries Special Collections.)

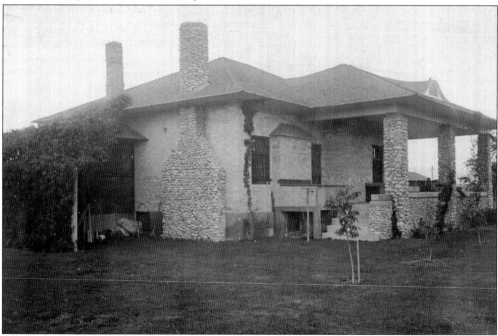

This is the W.R. Thomas House on the elite Fremont Street. Thomas was a lawyer who moved to Las Vegas in 1905 and was present at the land auction. He was president of the Vegas Artesian Water Syndicate. This company tried to raise money to dig artesian wells to provide water to land outside of Clark's Las Vegas town site. He built this house, and the W.R. Thomas Building, at the corner of Fremont and First Streets in February 1906. This "Thomas Block" was built through the Home Building and Loan Association. (Courtesy of UNLV Libraries Special Collections.)

Sheriff Sam Gay was six feet tall and started his career as a bouncer. In 1909, after Clark County was formed, he served as deputy under C.C. Corkhill. Corkhill fired him in 1910 for removing inmates from the city's metal jail during the summer heat and chaining them to the cottonwood trees at the Las Vegas Creek. Gay ran against Corkhill in 1910 and won. On January 4, 1919, Sheriff Sam Gay announced that he was going to enforce Prohibition to the letter. He served the force for 20 years and died in 1932. (Courtesy of (Nevada Historical Society Reno.)

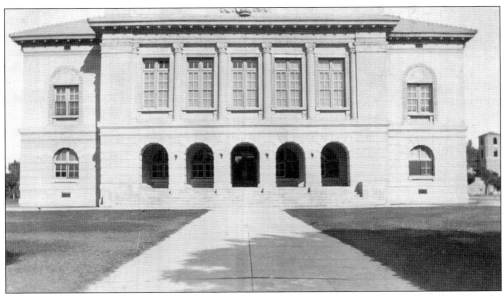

In 1914, a divorce cyclone hit Las Vegas. The permanent courthouse was completed in 1914 for a cost of $50,000. (Courtesy of UNLV Libraries Special Collections.)

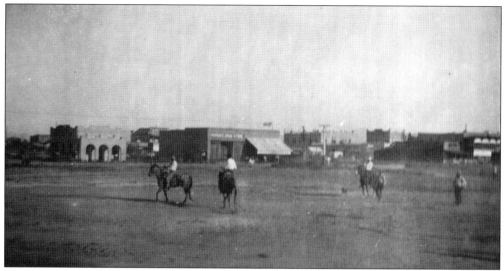

This is a Fourth of July celebration in 1913. The Eagles sponsored an all-day celebration on July 4, 1907. July 5 saw celebrations of the birth of Clark County from 1909. On July 4, 1910, Las Vegas laid a cornerstone for the new school. During the ceremony, they placed students' names and two American flags in the ground. (Courtesy of UNLV Libraries Special Collections.)

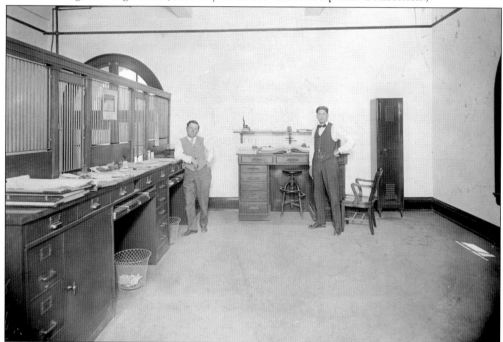

The county clerk's office is shown in 1915. The men are county clerk Harley Harmon (left) and treasurer Ed Clark. Years later, Harmon was credited with stemming the rising tide of lawlessness that swept the area with the start of the Boulder Dam construction. In 1905, he came as a crewmember on the San Pedro, Los Angeles & Salt Lake Railroad. He was a self-taught lawyer. In July 1909, he became the clerk of the newly created Clark County. It was his duties as county clerk that took him into law. He later married a commissioner's daughter. He prosecuted the case in which women first served on a jury. (Courtesy of UNLV Libraries Special Collections.)

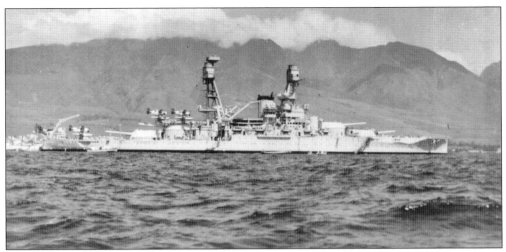

Sailors from the USS *Nevada* came to town on May 15, 1915. Later in history, the *Nevada* was involved at Pearl Harbor on December 7, 1941, but was able to survive the attack. *Nevada* was the only battleship to get underway, despite suffering numerous bomb hits. After repairs, the ship was returned to action in 1943. The ship's bell is now on exhibit at the Nevada State Museum Las Vegas. (Courtesy of UNLV Libraries Special Collections.)

Anne Martin traveled the state advocating for women's rights. In 1913, the Nevada legislature proposed an amendment to the state's constitution to permit women to vote. The *Las Vegas Age* reported how local women helped to promote the vote. In 1913, the Mesquite Club paid $25 to have American sociologist Charlotte Perkins Gilman speak on women's suffrage. The law passed on November 2, 1914, giving Nevada women the right to vote five years before the rest of the nation. (Courtesy of UNLV Libraries Special Collections.)

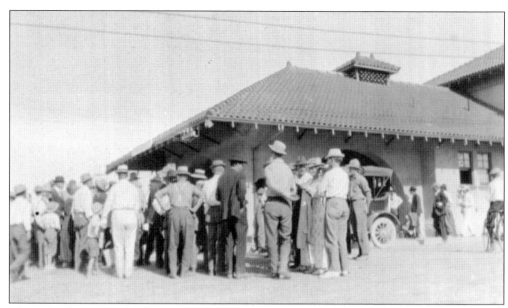

Men are enlisting for the draft in 1918 at the Las Vegas railroad station. World War I sparked a brief boom in the shipment of local minerals, food, and horses. However, it had no permanent effect on the local economy. (Courtesy of UNLV Libraries Special Collections.)

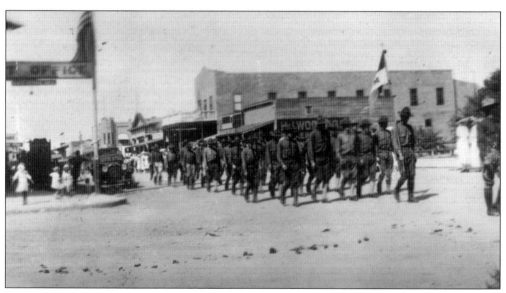

Here are World War I troops parading in 1917. America emerged from World War I with thousands of surplus planes as well as trained pilots who wanted to continue flying. Many aviators became barnstormers performing at airports across the country. This was Las Vegas's introduction to aviation. Late in 1919, aviation enthusiasts scraped out a dirt runway called Anderson Field south of the city limits. (Courtesy of UNLV Libraries Special Collections.)

Pictured are Charles Brown (left) and Spud Lake in World War I uniforms. Francis McNamee, wife of attorney Leo, formed a Red Cross chapter. It was chartered on April 6, 1917. The chapter gathered sweaters and coats and provided other necessities for the troops. In June 1917, they sponsored a war bond drive. (Courtesy of UNLV Libraries Special Collections.)

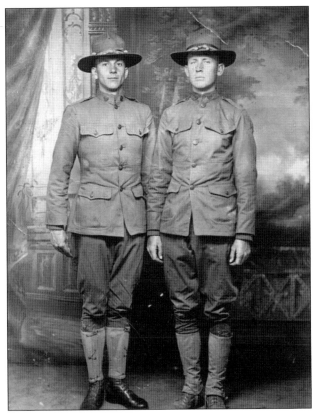

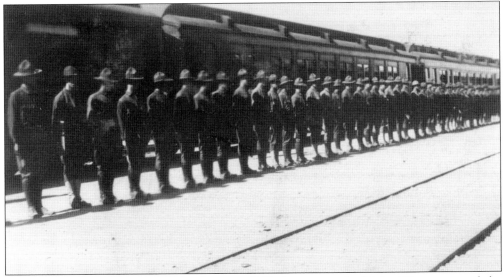

World War I troops are seen at the depot in 1917. As soon as the United States entered the war, the Red Cross contacted the Mesquite Club for help. The Mesquite Club knitted bedsocks and nightshirts for the troops. They had to get special permission from the Red Cross to do the knitting in their clubhouse. By all accounts, this was a good move as it brought club members together. They also contributed $38 to France to help war orphans. (Courtesy of UNLV Libraries Special Collections.)

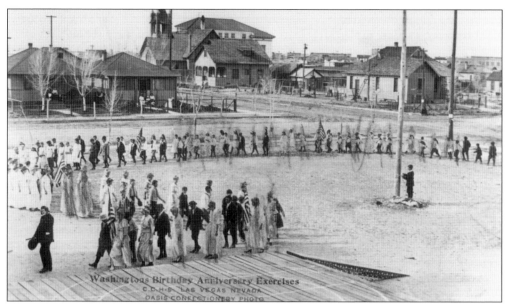

This is a celebration at Clark County High School for Washington's Birthday. The churches are seen in the background. The population expanded so much that a high school was added to the block south of the new school. That building served as Las Vegas High School until 1930. This school opened December 1917. It cost $55,000. A perpetual school crisis began in the late 1920s with the influx of new residents anticipating the Boulder Dam construction. (Courtesy of UNLV Libraries Special Collections.)

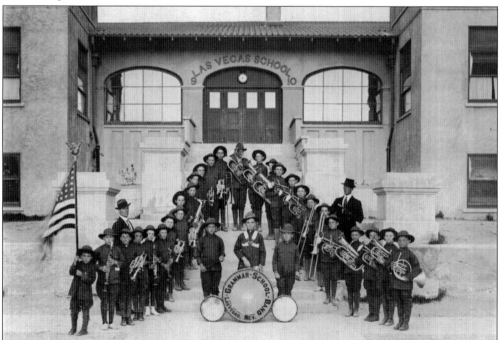

Here is a school band in 1917–1918. A band such as this one performed for a benefit concert for French nurses. One also performed at the Lost City pageant. (Courtesy of UNLV Libraries Special Collections.)

Here is the First State Bank at First and Fremont Streets in 1919. Los Angeles banker John S. Park was brought in to run this first bank. The first bookkeeper was Cyril Wengert. He later became bank manager and afterward was a top executive with Consolidated Power and Telephone Company. (Courtesy of UNLV Libraries Special Collections.)

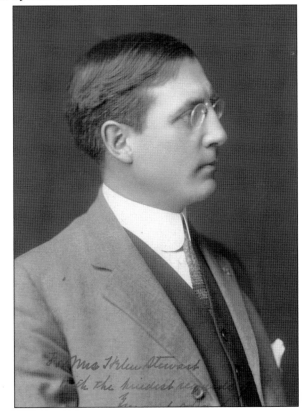

Governor Boyle signed a highway bill in 1919. For the first time, Las Vegas was linked to Reno. Ed Clark promoted highway construction. Governor Boyle also appointed the first members of the Colorado River Commission to investigate the possibility of a dam. These included Ed Clark, Harley Harmon, C.P. Squires, and James Scrugham. (Courtesy of UNLV Libraries Special Collections.)

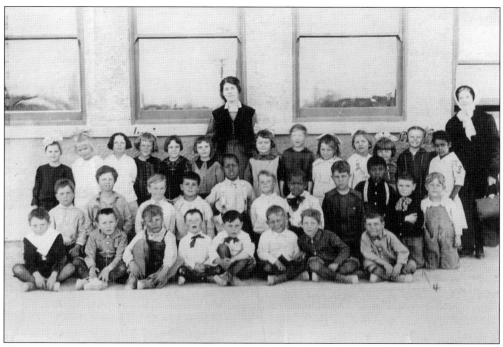

This is Buster Wilson's (of Spring Mountain Ranch) first-grade class at the Las Vegas Elementary School. Miss Phillips, his teacher, is standing at the rear. Buster is third from the right in the second row. School board member Helen J. Stewart, at far right, is visiting. (Courtesy of Mandy Keefer, Spring Mountain Ranch State Historic Park.)

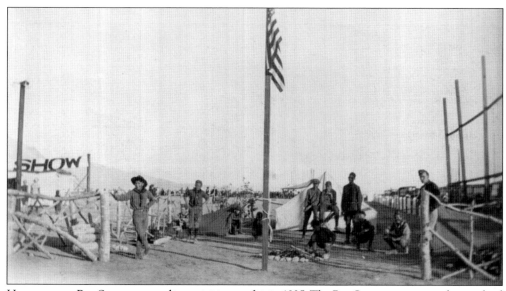

Here are some Boy Scouts engaged in activities at a fair in 1925. The Boy Scouts continue to be involved in many community activities today. (Courtesy of UNLV Libraries Special Collections.)

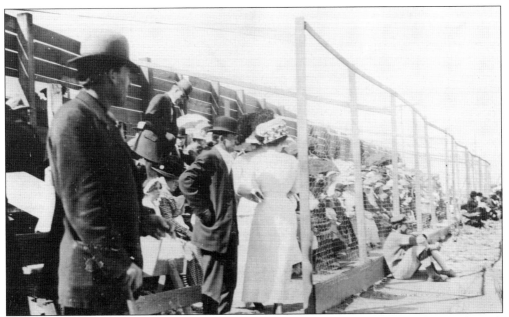

The first ball game was held in 1908. Baseball teams formed fairly soon after the city formed. The railroad sponsored several teams. In 1916, the Salt Lake City team held its spring training camp in Las Vegas. In 1925, Henry Wilson of Las Vegas, an African American, organized the city's first black team. Today, minor league baseball continues at the field. (Courtesy of UNLV Libraries Special Collections.)

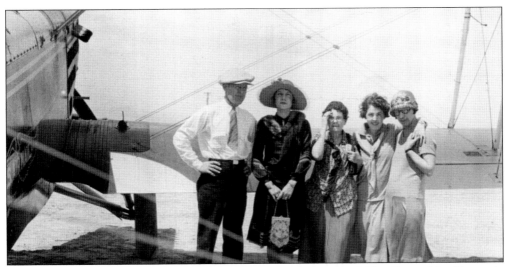

Pictured with the first mail plane are, from left to right, Dick Evans, Helen Evans, Mrs. Hancock, Doris Hancock, and Myrtle Morstad. (Courtesy of UNLV Libraries Special Collections.)

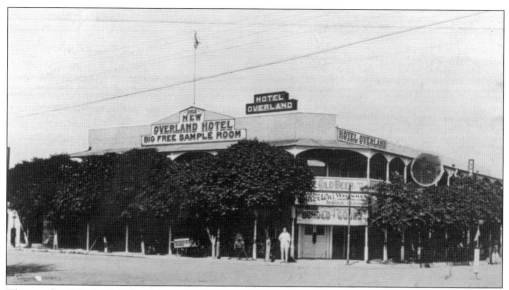

This is the "New" Overland Hotel in 1920; it had been rebuilt a decade before, after the 1911 fire. It advertised the Boulder Dam Stage Office. The "Big Free Sample Room" was a place for traveling salesmen to show off their products. This was a precursor to hotels promoting convention business. (Courtesy of UNLV Libraries Special Collections.)

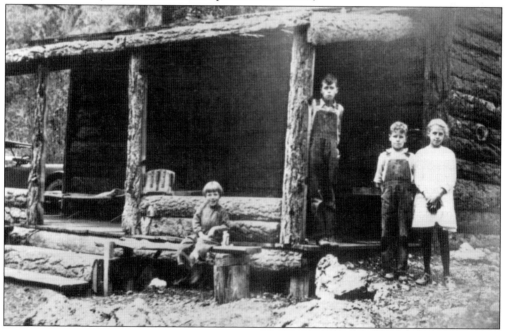

Here are the Von Tobel children in front of their cabin at Mount Charleston in 1921. The relentless sun beat down and drove many Las Vegans to escape to the cooler mountains in the summer. Shown here are from left to right, George, Jake, Edward Jr. and Elizabeth Von Tobel. It was a 2.5 hour trip to Mount Charleston in the family's Buick touring car. The family stayed in the cabin during the week and Ed Sr. brought up supplies of fresh meat, watermelon, vegetables, milk and ice every Saturday evening. (Courtesy of UNLV Libraries Special Collections.)

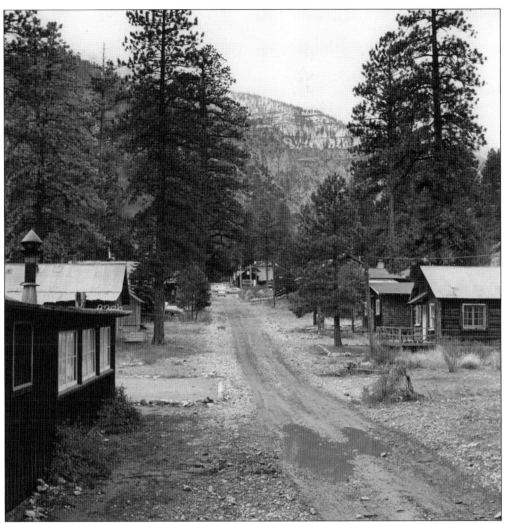

Pictured is Kyle Canyon at Mount Charleston in the 1960s. In the 1950s, Mount Charleston was an area where people would come and watch the atomic detonations from the Nevada Test Site. In the 1920's, the best way to beat the heat was not via electricity but by mobility. Those with money would rent tents or cabins for the season at Mount Charleston. Mount Charleston's Mary Jane Falls was named for Griffith's granddaughter Mary Jane Griffith. Mount Charleston was considered remote and primitive but desirable as a summer getaway. (Courtesy of Nevada State Museum Las Vegas.)

This image reflects the desert landscape and mountains seen from Las Vegas. As roads improved such as the Arrowhead trail, more townspeople ventured outside the city. (Courtesy of Nevada State Museum Las Vegas.)

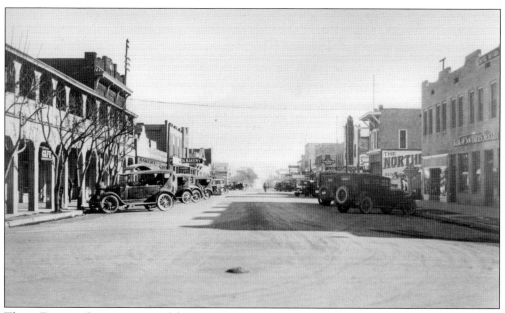

This is Fremont Street just east of the Main Street intersection in the 1920s. The Bank of Southern Nevada and the Northern Club are partially shown at right. Las Vegas got its first paved street in 1925. Thirty horses provided the power for the heavy equipment that paved Fremont Street from Main Street to Fifth Street. The 19-year-old redwood curbing was replaced with concrete, and North Main Street got a fresh coat of gravel. Although Fremont Street was restored, the other streets and alleys were a disgrace. Many were impassable. (Courtesy of UNLV Libraries Special Collections.)

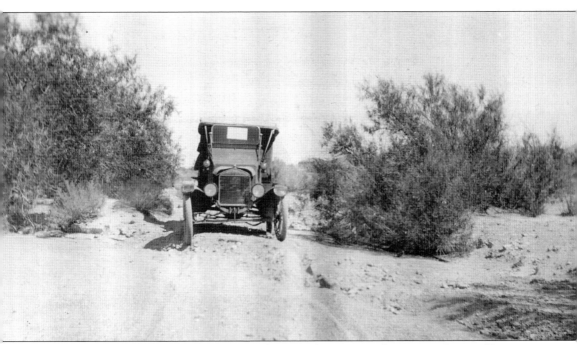

Pictured here is the modern way to travel in the 1920s; however, roads were treacherous. (Courtesy of UNLV Libraries Special Collections.)

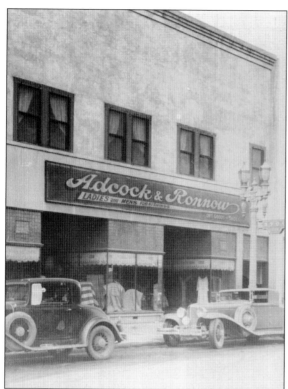

Adcock and Ronnow had the leading department store in Las Vegas for many years. This c. 1925 photograph shows the store building on the south side of Fremont Street between First Street and Casino Center Boulevard. The store sold "ladies and men's furnishings, dry goods and shoes." The store had many female customers who always had a chance to try on new dresses and hats. (Courtesy of UNLV Libraries Special Collections.)

In 1925, a fire broke out at the old Las Vegas Ranch in the cattle shed. The building was badly damaged and had to be torn down. Although the historical significance of the Mormon fort was recognized as early as 1911, no steps were taken to preserve the old fort until the 1930s, when the Daughters of the Utah Pioneers began their efforts. (Courtesy of UNLV Libraries Special Collections.)

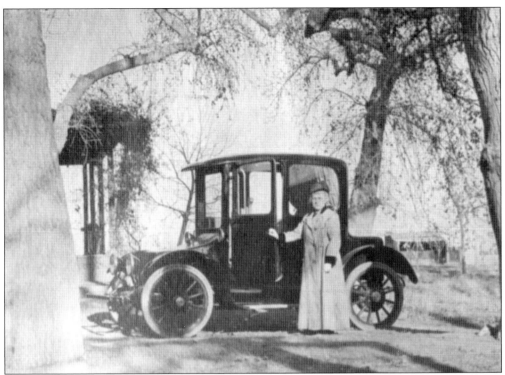

This elegant lady is Mrs. John S. Park, wife of the early Las Vegas banker. She is about to go for a ride in the only electric car in Las Vegas. The picture was taken about 1920. Many young people were invited to ride for the adventure. (Courtesy of UNLV Libraries Special Collections.)

This is Sunrise Mountain in 1924, east of Las Vegas. Even though it is over 3.3 miles higher than Frenchman Mountain, many people mistakenly refer to Frenchman Mountain as Sunrise Mountain since the sun rises from behind it. (Courtesy of UNLV Libraries Special Collections.)

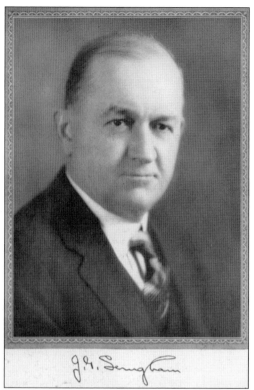

Col. James Scrugham was elected governor in 1923 when mining and agriculture were the dominant industries and political power was based in the North. He was interested in archeology and would see the prehistory of his state documented. He helped push forward the excavation of a site using world-famous archaeologist Mark Harrington. The area won attention for the discovery of ancestral Puebloan ruins known as Pueblo Grande de Nevada and became a tourist attraction known as "Lost City." (Courtesy of Nevada State Museum Carson City.)

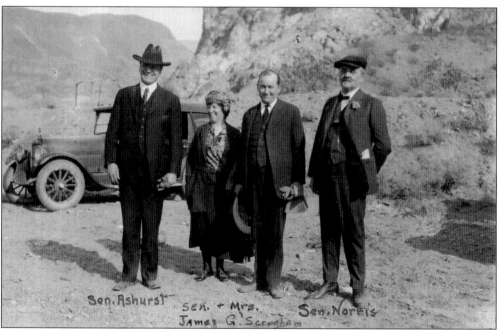

In 1917, Gov. Emmet Boyle offered James Scrugham the job of state engineer. His life's work was the construction of a high dam on the Colorado River. He saw his beloved dam completed in 1935. He was the first governor to promote setting aside public lands for recreational purposes. This was the beginning of the Nevada State Parks. (Courtesy of UNLV Libraries Special Collections.)

In 1922, D.G. Lorenzi started a resort two miles northwest of the railroad tracks on land that is now Lorenzi Park. He had purchased the 80 acres with agriculture in mind but changed his mind to recreation after discovering underground water. He was a stonemason and created two artificial lakes for boating, a dance pavilion, and a swimming pool. It was the place to go for the Fourth of July. (Courtesy of UNLV Libraries Special Collections.)

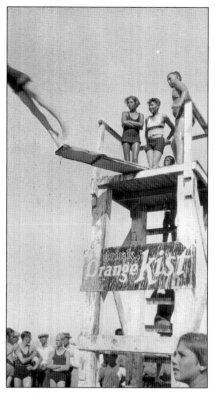

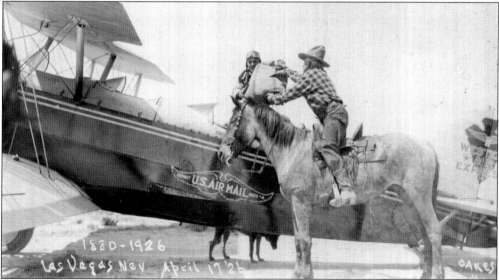

In April 1926, Western Air Express pilot Maury Graham left Vail Field near Los Angeles with two passengers on the way to Salt Lake City. Cruising at 175 miles per hour, he arrived at his refueling stop at Las Vegas's Rockwell Field. The landing marked the first scheduled air passenger flight in Las Vegas. Graham's instructions for the remainder of the flight were simple: stay to the right of the Union Pacific Railroad tracks to avoid colliding with the southbound flight. This image shows Pony Express rider Bill Morgan passing mail to the mail plane pilot. (Courtesy of UNLV Libraries Special Collections.)

This is the old Las Vegas Ranch Bridge with Jean Quaid on it. In 1905, the first of many resort operations were established at the old ranch. Using primarily the old ranch house and the grounds surrounding it, Harry R. Beale erected wood and canvas tents for tourists. While a portion of the ranch was used as a resort or tourist camp, much of it remained in agriculture. (Courtesy of UNLV Libraries Special Collections.)

Beale erected a swimming pool and a dance floor. The Beale resort lasted only one year. Shown next to the swimming pool at Las Vegas Ranch is Theresa Doolittle (right). Dairy farming began in 1914 at the old ranch. In 1915, Theresa's father Dwight Doolittle continued the resort operation and leased the dairy business to Joseph Foremaster. (Courtesy of UNLV Libraries Special Collections.)

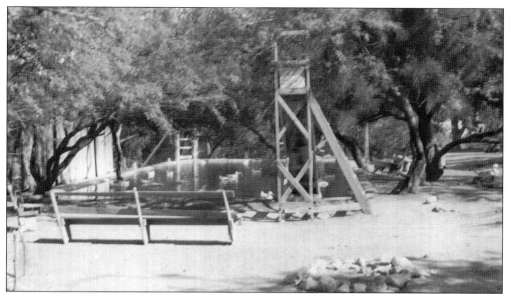

The old ranch property became a community park. Foremaster ran the dairy until 1929. He grew vegetables and raised hogs until 1930. (Courtesy of UNLV Libraries Special Collections.)

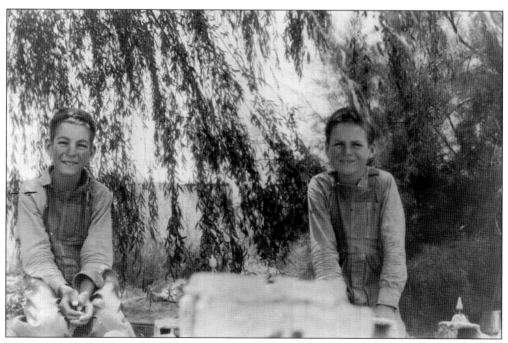

Pictured are Ted (left) and Bill Gilcrease as young boys. Their orchards are still enjoyed today, especially around Halloween as young people pick pumpkins. (Courtesy of UNLV Libraries Special Collections.)

Here is a lemonade stand in the summer of 1930. The sign reads, "Ice cold lemonade a penny a glass." The stand was located on the 500 block of South Second Street. The streets were unpaved. The large shade-giving cottonwood trees were planted around 1912 by the ladies of the Mesquite Club. The houses across the street were among the 64 houses built by the railroad in 1911–1912. The boys in the picture are the Harringtons. The girl is Dorothy Snider. (Courtesy of UNLV Libraries Special Collections.)

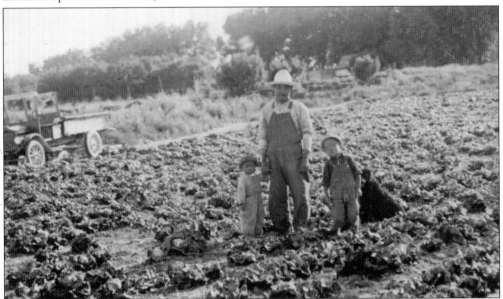

Pictured here are Bill Tomiyasu and his sons in his lettuce patch in 1923. From left to right are Kiyo, Bill, and Nanyu. Tomiyasu was a Japanese-born immigrant who came to Nevada in 1914. He was one of the first Asian Americans to settle in the valley. His intention was to own and operate a ranch southwest of town. However, ownership was not as easy in Nevada as it had been in California for immigrants. His main money crop was alfalfa. (Courtesy of UNLV Libraries Special Collections.)

Here are Tomiyasu and sons in formal dress. In the 1930s, Tomiyasu struck a great coup for the family business when he landed a long-term contract with Six Companies, which was the name given to the six Western firms hired by the US Bureau of Reclamation to build Boulder Dam. Tomiyasu supplied food to the construction camp mess halls. He also sold to Las Vegas residents and restaurants. (Courtesy of UNLV Libraries Special Collections.)

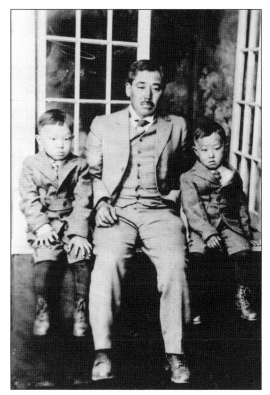

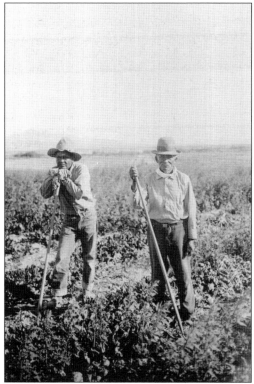

Here are Indian workers on the Tomiyasu farm. Tomiyasu had innovative farming techniques and fed the dam's workers with fruits and vegetables, which included tomatoes, asparagus, watermelons, and cantaloupe. Prior to his arrival, these items had to be shipped in from outside Las Vegas, which added to the expense. (Courtesy of UNLV Libraries Special Collections.)

This is the 1929 senior skip day from Las Vegas High School at Mount Charleston. This was a tradition for many years. (Courtesy of Nevada State Museum Las Vegas.)

Here is one of the first theaters in Las Vegas. A big evening date was a movie at the theater followed by a banana split at the Sweetshop. This was popular with high school students. (Courtesy of UNLV Libraries Special Collections.)

William Stewart lost the first election for county commissioner on the Republican ticket in 1910. However, he did become one of the first city commissioners when Las Vegas was incorporated in 1911. He won the long term county commissioner seat in 1920 while Jim Cashman won the short term seat. They both ran unopposed in 1924. He was interested in roads and highways. Then, he became chair of the commission in 1925. (Courtesy of Nevada State Museum Las Vegas.)

Here is County Commissioner Bill Stewart with his developmentally disabled daughter Helen J. Stewart, who was named after her famous grandmother, in the 1920s. A special needs school was named after her. (Courtesy of Nevada State Museum Las Vegas.)

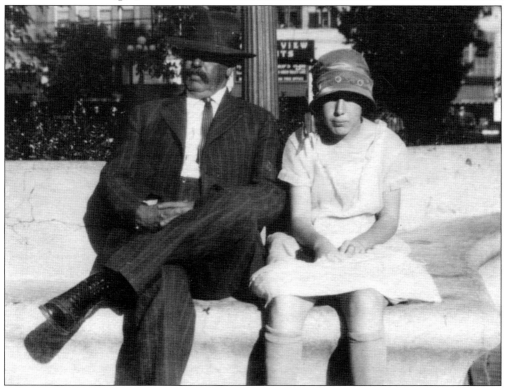

An educator for 40 years, Maude Frazier left an impact on the education system in the valley. She was superintendent of Las Vegas schools for 19 years. She also served in the Nevada state legislature for 12 years. The first building on the University of Nevada Las Vegas campus was named after her. This historic building was torn down in 2010. (Courtesy of UNLV Libraries Special Collections.)

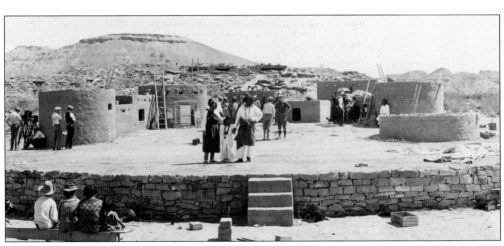

This was the stage for the Lost City Pageant conducted in May 1925 to showcase the archeological finds of ancestral Puebloans near St. Thomas. American Indians demonstrated their culture. The Union Pacific ran a special train out to Overton to take people to the pageant. (Courtesy of UNLV Libraries Special Collections.)

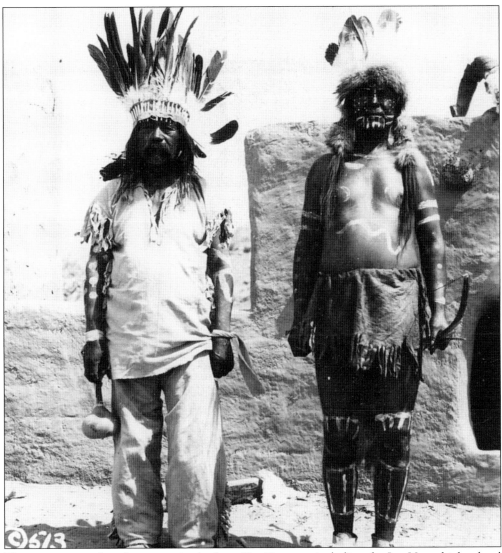

There were several performances in the Lost City Pageant, including the Las Vegas high school bands. Later, the rising waters of Lake Mead covered the archeological sites of the Lost City. (Courtesy of UNLV Libraries Special Collections.)

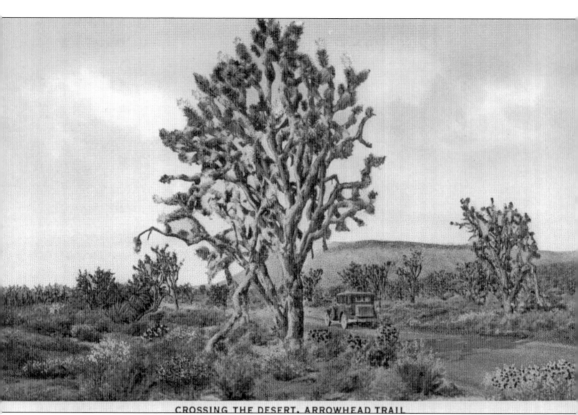

CROSSING THE DESERT, ARROWHEAD TRAIL

The new road systems made traveling the desert easier. Anne Martin drove around the state in a car similar to this one to promote women's suffrage. She also campaigned for US Senate by driving a car around the state. (Courtesy of UNLV Libraries Special Collections.)

Five

GATEWAY TO
BOULDER DAM

From 1905, Las Vegas remained a railroad town until the building of Boulder Dam. As early as 1905, the federal government and residents of the Southwest had discussed the possibilities of damming the Colorado River. In 1921, the Colorado River Commission was formed to prepare an agreement regarding the use of the Colorado River. It included representatives from all the states bordering the Colorado River (Nevada, California, Arizona, New Mexico, Utah, Wyoming and Colorado) and the federal government. The federal representative, appointed by President Harding in 1921, was Secretary of Commerce Herbert Hoover. The League of the Southwest started talking up a dam. Squires approached Nevada governor Emmet Boyle to join. However, he declined and named Squires to take his place. Eventually the Colorado River Compact was worked out and signed by six of the seven state representatives in 1922. Arizona declined until 1939.

In December 1928, the town woke up with a start, as President Coolidge signed a bill authorizing the construction of the giant public work, the Boulder Dam Project on the Colorado River near Las Vegas. The final bill, heavily rewritten by Hoover who had continued interest in the project was submitted in 1928. Congress passed the Boulder Canyon Project Act (the Swing-Johnson Bill) on December 21, 1928, signed into law by President Coolidge. When the news reached Las Vegas, whistles were blown and bells were rung to celebrate the news. Although the country was in a deep economic depression, this was not the case in Las Vegas with the plans to build the dam. Carloads of building materials passed through Las Vegas for shipment to the dam. Real estate agents began to build hotel rooms, and houses were demolished to make room for office blocks and more hotels.

The Bureau of Reclamation took over the Old Las Vegas Mormon Fort while preparing for construction of the dam. It repaired the adobe building at the old fort and put in a concrete floor. It was then used for a gravel-testing headquarters for the dam. Many of the workers lived in Las Vegas prior to the establishment of Boulder City.

Las Vegas hoped to see dam workers. The period from 1920 to 1935 was one of the most impressive in the city's history. Hoover Boulder/Hoover Dam had a tremendous impact on the development of the town. The dam was built during the Great Depression and provided jobs for thousands of men from around the country and the world. It was an engineering marvel. But it also created Lake Mead, which continues to provide water for cities in the dry Southwest. It controls floods and provides recreation and jobs for thousands. The dam helped save and build Las Vegas.

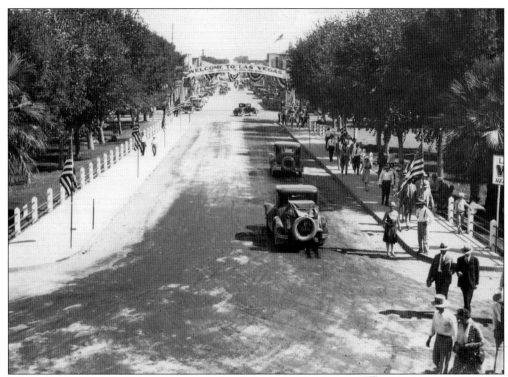

"Welcome to Las Vegas, the gateway to Boulder Dam" was strung across the street for Secretary of the Interior Ray Lyman Wilbur to see. He was the man to decide if Las Vegas would be the center of the dam or if a new city would need to be built. Downtown merchants and home owners promoted a "paint-up" and "clean-up" campaign. The red lights of Block 16 were extinguished. Later, it was learned he was not impressed. In the group along the sidewalk are Secretary Wilbur; Dr. Elwood Mead, commissioner of the Reclamation Committee; Sens. Key Pittman and Tasker Oddie; Gov. Fred Balzar; Congressman Samuel Arentz; and former governor James Scrugham. (Courtesy of UNLV Libraries Special Collections.)

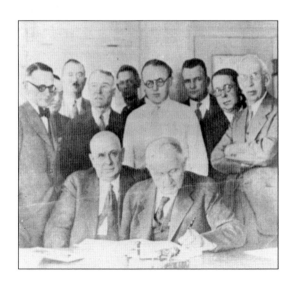

Signing the contract for the construction of Hoover Dam in the office of Boulder Canyon Project on April 11, 1931, are Construction Engineer Walker Young, John C. Page Office Engineer (standing in back); Walter R. Young (standing left with glasses); Al Cahlan (standing, white shirt and glasses) Charles "Pop" Squires (standing right, arms crossed); seated left to right Raymond Walter and Dr. Elwood Mead (Courtesy of UNLV Libraries Special Collections.)

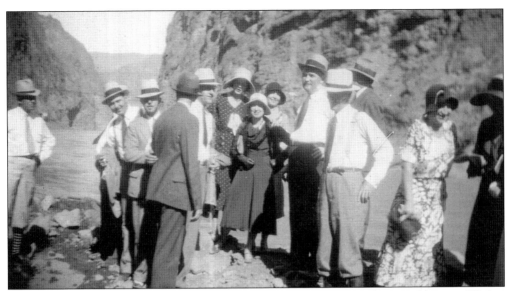

Pictured here is a group of people on the Colorado River at the start of dam construction. Worker housing at Boulder City was not yet ready, and hundreds of workers and their families crowded into Williamsville (named for the United States Marshal Claude Williams who lived there) beside the Colorado River. (Courtesy of UNLV Libraries Special Collections.)

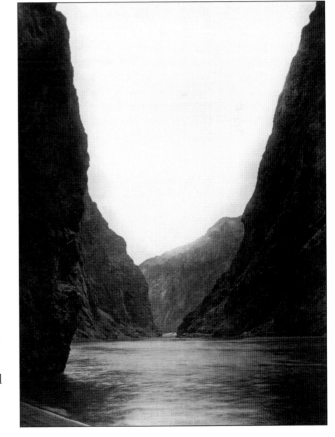

This picture was taken looking upstream on the Colorado River near the Black Canyon Dam site. Talk started in 1920 about harnessing the Colorado River with a dam. Speculators hoped that if Congress passed a bill for a dam, the people of Las Vegas would see a big real estate boom. In 1925, it was supposed to be discussed in the next Congress. The legislation did not pass until 1928. The dam was finished in 1935. (Courtesy of UNLV Libraries Special Collections.)

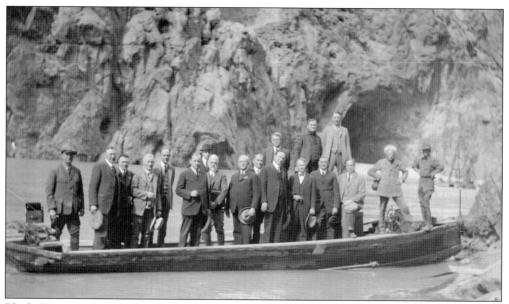

Black Canyon was picked as the site but Boulder stuck to the project. The Congressional party visits Black Canyon on March 3, 1923. Investigations were being made at both Black Canyon and Boulder Canyon to see which place would be more feasible for such a giant construction project. (Courtesy of UNLV Libraries Special Collections.)

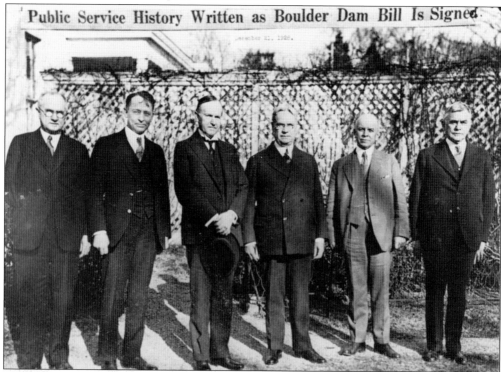

Here are the signers of the bill. Las Vegas celebrated what promised to be an economic boom. Downstream lots started selling rapidly. The Union Pacific announced plans to build a branch to the dam and expand the downtown yards. (Courtesy of UNLV Libraries Special Collections.)

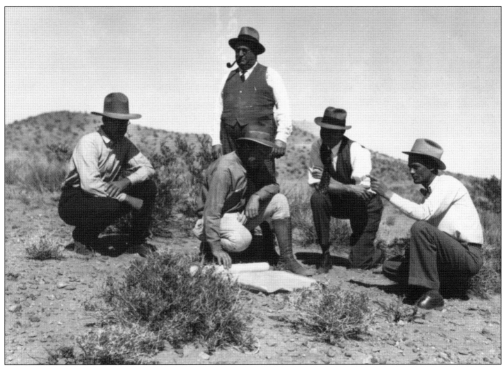

Pictured are men representing the Six Companies on March 13, 1931. This was the main company that worked on the dam. The workmen lived in Las Vegas prior to housing being built for them in Boulder City. Almost overnight, the town went from a one-horse economy almost totally dependent on the railroad to a diversified economy based on the Six Companies and its suppliers. Pictured are John C. Page, engineer for the Bureau of Reclamation, kneeling on the right and pointing is Frank Crown, Boulder Canyon Project Superintendant. (Courtesy of UNLV Libraries Special Collections.)

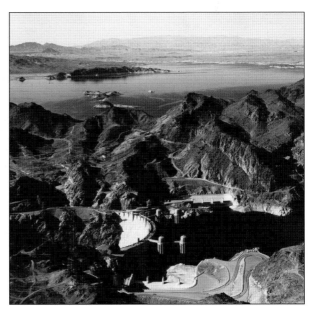

Pictured is the Hoover Dam today. The construction period from 1931 to 1935 was a transforming time for Las Vegas. It demonstrated that Las Vegas's future was in tourism. Workers reported to camp for field employees at Boulder Canyon, which was 50 miles from Las Vegas. All of the supplies for the work and the subsistence of the men working there had to be brought from Las Vegas. Von Tobel Lumber provided the wood. The dam's workforce unleashed a wave of consumer spending as the workers headed to Las Vegas to spend their idle hours. (Courtesy of UNLV Libraries Special Collections.)

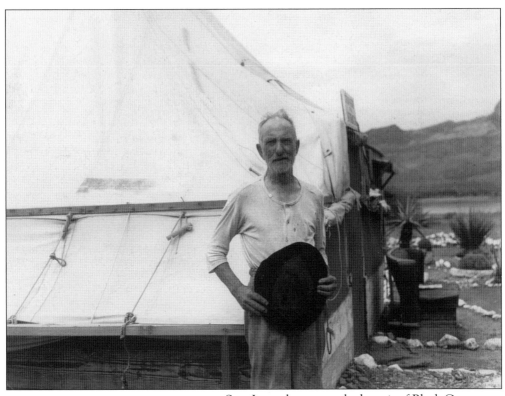

Sam Jones, known as the hermit of Black Canyon, lived in Ragtown on the shore of the Colorado River near Black Canyon in 1931. Families pitched tents here and hoped for work on the dam. (Courtesy of UNLV Libraries Special Collections.)

Here the rising waters of Lake Mead are covering the archaeological sites of the Lost City. The movement of the water ruined the work done by the archeologists. Artifacts were saved and put in a museum in Overton. Due to the present-day water levels, some of the artifacts left behind have resurfaced. (Courtesy of UNLV Libraries Special Collections.)

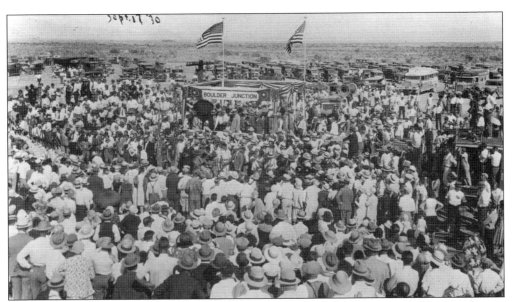

This event took place in September 1930 when the Union Pacific line was extended for construction at the dam site and the construction of Boulder City. It was a celebratory day. However, when Interior Secretary Ray Wilbur announced that the dam would be named for the unpopular Pres. Herbert Hoover, the mood quickly changed. (Courtesy of UNLV Libraries Special Collections.)

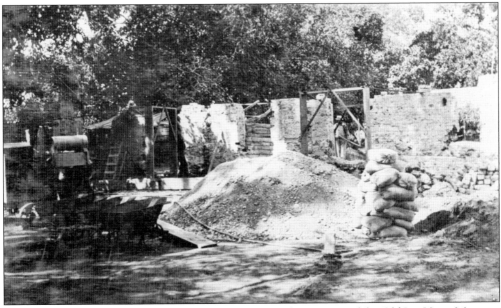

The Bureau of Reclamation subleased from Foremaster the remains of the Old Las Vegas Mormon Fort bastion and adjacent farm buildings together with 1,000 feet of land. This was the site of gravel testing for Hoover Dam on September 19, 1929. The development of Las Vegas went full circle—back to the old Stewart Ranch. (Courtesy of UNLV Libraries Special Collections.)

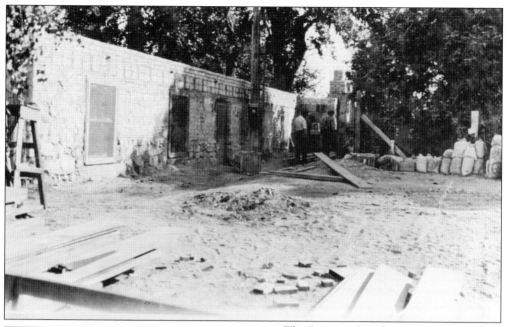

The Bureau of Reclamation had offices in Las Vegas directing the preliminary investigations into the building of the dam. In 1930, the Bureau of Reclamation added an adobe curing room to the north end of the old fort. Cutting a door in the north wall allowed access to the addition. Soon after the Bureau of Reclamation left, the one-brick-thick walls of the curing room either collapsed or were torn down. This was the main activity at the fort during this time. (Courtesy of UNLV Libraries Special Collections.)

Here is the interior of the lab at the old fort. When the Bureau of Reclamation leased the old fort building in 1929, it rebuilt most of the east wall and other portions of the structure. Changes in the building included putting in a plank ceiling, which was covered with earth and tarpaper; laying a cement floor; and installing electrical wiring and plumbing that met city ordinances. New doors and windows were also cut, and the building was divided into three rooms. (Courtesy of UNLV Libraries Special Collections.)

The severely damaged parts of the bastion and adjacent farm buildings were removed, and new adobe was added to complete the enclosure. A number of doors and windows were cut in the old adobe walls, and a concrete floor was placed inside. The Bureau of Reclamation operated until 1930, when the concrete testing was moved to Boulder City. (Courtesy of UNLV Libraries Special Collections.)

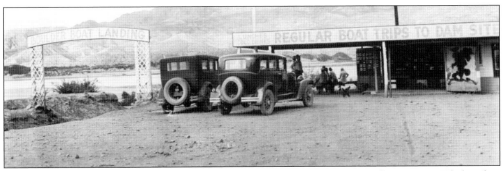

Here, people from Las Vegas come to the Boulder Landing for recreational activities. While other people around the country were suffering from the Great Depression, people in Las Vegas were enjoying their new recreational activities. (Courtesy of UNLV Libraries Special Collections.)

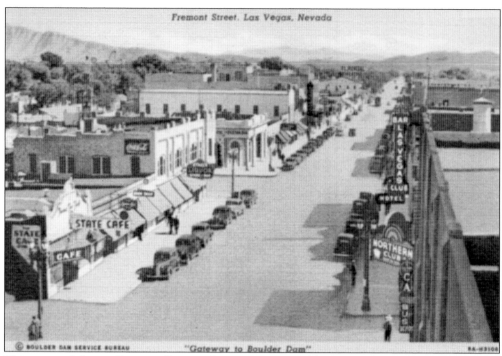

Fremont Street, Las Vegas, Nevada

"Gateway to Boulder Dam"

This postcard depicts Fremont Street—the gateway to Boulder Dam. The writer of the postcard said that it was hot here, and he had driven 160 miles in the desert. (Courtesy of UNLV Libraries Special Collections.)

Pres. Franklin D. Roosevelt came to dedicate the Hoover Dam on September 30, 1935. His visit was originally scheduled to bypass Las Vegas. Ed Clark thought it would be a shame to miss all the free publicity. He enlisted the aid of Nevada's senior Democratic senator Key Pittman, who was one of Roosevelt's allies. The two Democrats won the change. Now, the plan included a trip to Mount Charleston. (Courtesy of UNLV Libraries Special Collections.)

Six

A TOWN REMEMBERS
ITS PAST

In 1944, the Daughters of the Utah Pioneers began the campaign to preserve the old adobe fort building. The Daughters obtained a lease on the ranch to preserve it as a museum. In 1955, the Union Pacific sold the old ranch property to the Mormon Church, the City of Las Vegas, and the Benevolent and Protective Order of the Elks. On the land sold to the Elks was the ranch house and the old fort. A restaurant was run in the ranch house until 1963, when the Elks had it demolished. In the meantime, the Daughters of the Utah Pioneers continued their struggle to preserve the old fort by building a canopy over the eroding adobe. In 1971, the City of Las Vegas purchased the property on which the old fort stands. The Preservation Association of Clark County, formed in 1974, also helped with the preservation efforts at the fort. The Daughters were instrumental in the property becoming a Nevada State Park.

Today, other volunteer groups, such as the Southern Nevada Living History group, help keep the past alive through reenactments at the Old Las Vegas Mormon Fort State Historic Park. Also, women's groups such as the Mesquite Club, and Helldorado Days, sponsored by the Las Vegas Centennial Commission, continue to inform the public of days gone by. Many of the groups founded over 100 years ago still exist today.

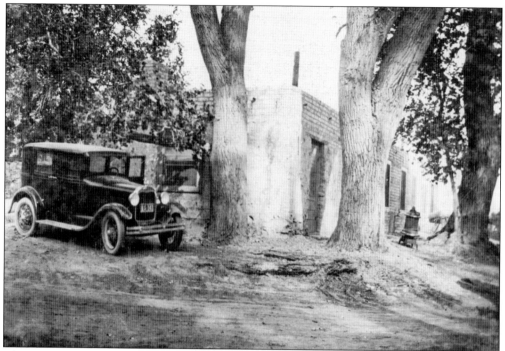

This is the old fort in 1931 when the ranch was used as a tourist camp, dairy farm, and slaughterhouse from 1931 to 1944. (Courtesy of UNLV Libraries Special Collections.)

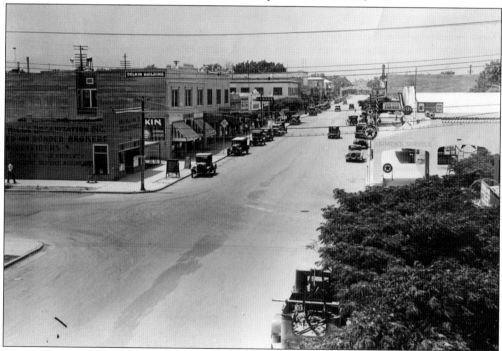

The *Las Vegas Review-Journal* described the town as on the rise in 1925. It had five churches, two banks, two newspapers, electric lights, telephones, a good library, and all the improvements of modern society. (Courtesy of UNLV Libraries Special Collections.)

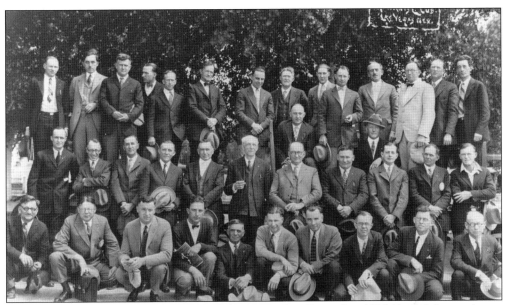

This is the original Las Vegas Kiwanis Club organized in December 1925. From left to right are (first row) Dick Roschl, Abe Whiteneck, P. Pickles, Coach Craven, Mac McGriff, Warren Parker, Monty Montague, Art Harrington, McHenry Stockton, and Ed Smith; (second row) Le Ray Neagle, Hal Buzick, Bill Fulton, Charley Horsey, Tom Carroll, Alonzo Delkin, Doc Bulette, Ira Earl, "Doc" Earl Padgett, Warren Woodard, and Harry Anderson; (third row) Harvey Perry and Jim Down; (fourth row) Lon Derkin, Ed Dupray, Gene Ward, J. Judson, Dean Bingham, Steve Whitehead, E.K. Kirschman, Doc Conger, Carl Rau, George Hardman, Louis Oakes, Dr. Bunce, Wally Roads, and Joe Harbison. This club continues today and carries on traditions from the early days of Las Vegas. (Courtesy of UNLV Libraries Special Collections.)

Pioneer Helen J. Stewart was called the "First Lady of Las Vegas" for her contributions to the development of early Las Vegas. She is remembered at the Old Las Vegas Mormon Fort State Historic Park with a statue dedicated to her. Around the statue are artifacts that recall her impact: the mesquite bush for her founding of the Mesquite Club, Paiute baskets for her support of the Paiute people, the Episcopal Common Prayer book for her founding of Christ Church Episcopal, and letters representing those she wrote to her daughter and her role as the first postmaster of Las Vegas. Pictured here are Benjamin Victor, sculptor of the statue, and Dr. Linda Karen Miller, author and interpreter, on December 3, 2011. (Courtesy of UNLV Libraries Special Collections.)

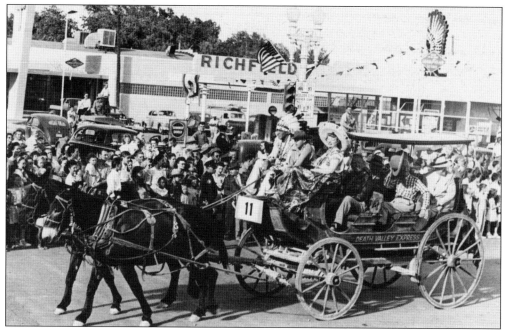

This is the first Helldorado parade in 1935. Pop Squires is in plaid. This parade continues today and is a reflection of times gone by. It helps bring back into perspective the life and times of the early pioneers in Las Vegas. (Courtesy of UNLV Libraries Special Collections.)

This is called "Helldorado fun" from the first Helldorado in 1935. Kneeling is John F. Cahlan, editor of the *Las Vegas Review-Journal*. The man with the coonskin cap is Pat Gallagher, deputy US marshal and old-time Las Vegas resident. Mounted on a donkey is the Las Vegas Helldorado's first beauty queen Louise Crowe, sister of Jerry Crowe and Stella Crowe. The bartender is Berto Testolin at the Apache Bar, and the man with the cigar is Bud Bodell, Boulder City chief of police. (Courtesy of UNLV Libraries Special Collections.)

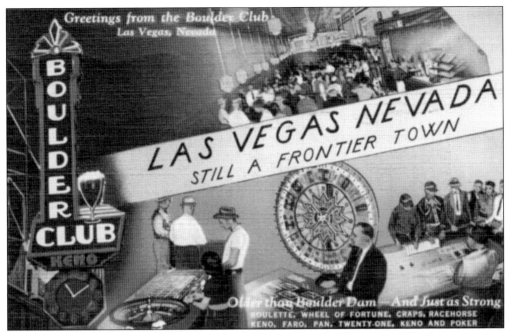

This postcard reflects the same theme as the cover, that Las Vegas is still a frontier town. Today, recreations continue to remind the populace of the past. (Courtesy of UNLV Libraries Special Collections.)

Each year, "Owner's Day" is celebrated at Spring Mountain Ranch State Park. This includes a variety of owners from the early Wilsons to Howard Hughes and Vera Krupp. (Courtesy of Mandy Keefer, Spring Mountain Ranch State Park.)

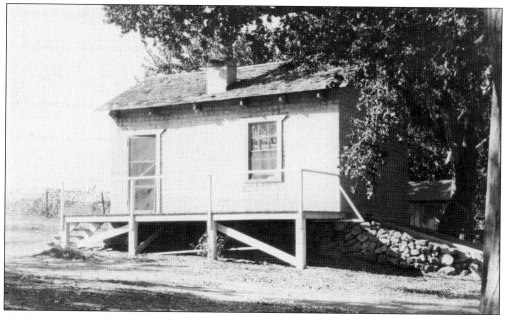

This is the adobe house at the Old Kiel Ranch. The restoration and development project has had several funding problems. The reconstruction of the north wall, which collapsed several years ago, is completed. The dilapidated canopy over the adobe was removed. The next phase is landscaping the site. Although funding is limited, preservation efforts continue. (Courtesy of UNLV Libraries Special Collections.)

Pictured at the governor's mansion are the former first lady of Nevada Dawn Gibbons (2007–2010) with author Dr. Linda Miller as Helen J. Stewart. The event was "Pink Tea" to celebrate some of the famous women in Nevada's history. Former first lady Una Dickerson wore the dress on display. Her husband was acting governor from 1908 to 1911. She was the first Nevada-born first lady. Her daughter, June, born on September 2, 1909, was the only child born in the governor's mansion. (Author's collection.)

This is the centennial celebration of the Mesquite Club in February 2011. Pictured from left to right are Mayor Carolyn Goodman, author Dr. Linda Miller, former mayor Oscar Goodman, and Jeanne Greenawald, Mesquite Club member. (Author's collection.)

This is former Old Las Vegas Mormon Fort State Historic Park supervisor Chris Macek as O.D. Gass, one of the original owners of the ranch. Schoolchildren regularly visit the park to learn about the role that the old fort played in the history of early Las Vegas. (Author's collection.)

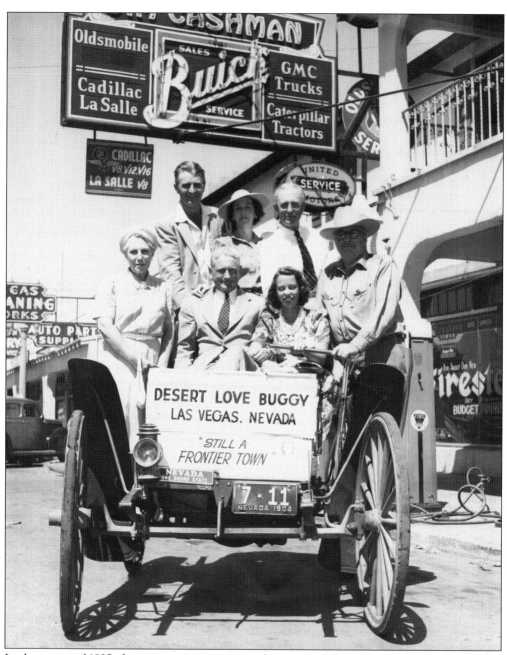

In the spring of 1935, there was grim news everywhere around the country except in Las Vegas. Boulder Dam was completed, and the town was getting ready to throw a party for the 30th anniversary of its founding. Helldorado Days was a four-day event in which people dressed in Western clothes. Rex Bell, the actor and Searchlight rancher, came to the event. It was a tremendous success and helped to create the slogan: "Still a Frontier Town." Pictured are Jim Cashman (bottom row center) and his wife Leah (bottom row left). The car is presently on display at the Nevada State Museum Las Vegas. (Courtesy of UNLV Libraries Special Collections.)

This is a recreation of the Las Vegas Creek at the Old Las Vegas Mormon Fort State Historic Park. It was done through the efforts of the Nevada State Parks. Today, visitors can stroll through the park and think about the importance of this creek in the development of early Las Vegas. (Author's collection.)

BIBLIOGRAPHY

Archeological Reconnaissance of the Las Vegas Mormon Fort. Las Vegas, NV: prepared by WESTEC Services for the City of Las Vegas, 1981.

Cling, Carol. "Pioneer Spirit." *Las Vegas Review-Journal.* November 2011: 31.

"The First 100." *Las Vegas Review-Journal.* www.lvrj.com/1st100/part1.

Green, Michael and Eugene P. Moehring. *Las Vegas, a Centennial History.* Reno and Las Vegas, NV: University of Nevada Press, 2005.

Nevada State Museum, Las Vegas. *The Letters of Helen J. Stewart.* Las Vegas, NV: Nevada Museum Association, 2009.

Paher, Stanley. *Las Vegas: As It Began, As It Grows.* Las Vegas, NV: Nevada Publications, 1971.

Pesek, Margo Bartlett. "Visit Old Mormon Fort to Learn City's History." *Las Vegas Review-Journal.* January 1, 2012.

Roske, Ralph. *Las Vegas a Desert Paradise.* Tulsa, OK: Continental Heritage Press, 1986.

Shaw, Mary. *Mesquite Club: 100 Years of Friendship and Service, 1911–2011.* Las Vegas, NV: 2011.

UNLV University Libraries Digital Collections. http://digital.library.unlv.edu/boomtown.

Whitely, Joan Burkhart. *Young Las Vegas before the Future Found Us.* Las Vegas, NV: Stephens Press, 2005.

Wright, Frank. *Nevada Yesterdays.* Las Vegas, NV: Stephens Press, 2005.

ABOUT THE ORGANIZATION

The Friends of the Fort is a nonprofit organization that assists the Old Las Vegas Mormon Fort State Historic Park in Las Vegas, Nevada. This historic park marks the site of the first Mormon settlement in Las Vegas in 1855. After the Mormons left in 1857, miner O.D. Gass, who occupied the area in the 1860s, built the ranch house. Later, it was the property of Archibald and Helen Stewart.

The Daughters of the Utah Pioneers, descendants of the original settlers, rescued the remnants of the old fort and ranch in the 1940s. They remain active in volunteer efforts today.

Chartered with the state of Nevada in 1983, the Friends of the Fort desired to lease the "Old Mormon Fort" from the City of Las Vegas to raise awareness of the pubic to the historical importance of the structure. They reopened the fort and provided educational tours of the site and lobbied the state to recognize its place in Nevada history. Finally in 1991, the property was acquired by the Nevada State Parks and named the Old Las Vegas Mormon Fort State Historic Park.

The Friends of the Fort's mission is to assist the state of Nevada and staff of the Old Las Vegas Mormon Fort State Historic Park in preserving and promoting the historical importance of the site through funds collected by the Friends of the Fort. The author's proceeds from this book will go to the Friends of the Fort to help in its educational endeavors to increase the awareness of the public of the historical site through training and supporting a volunteer docent program. Dr. Linda Karen Miller, vice president of the Friends of the Fort board, compiled this book on a volunteer basis.

Yearly programs include Settlement Day breakfast, Nevada Day, and Helen J. Stewart tea. After funding from the Las Vegas Centennial Commission, the Friends of the Fort commissioned a statue dedicated to Helen J. Stewart by Benjamin Victor and a documentary by Gwen Clancy.

The Friends of the Fort also seek to support research efforts to further establish the fort's role through writing grants and creating proposals for programs and research. This book will continue educational efforts to promote the legacy of the fort and the ranch once owned by Helen J. Stewart.

DISCOVER THOUSANDS OF LOCAL HISTORY BOOKS FEATURING MILLIONS OF VINTAGE IMAGES

Arcadia Publishing, the leading local history publisher in the United States, is committed to making history accessible and meaningful through publishing books that celebrate and preserve the heritage of America's people and places.

Find more books like this at
www.arcadiapublishing.com

Search for your hometown history, your old stomping grounds, and even your favorite sports team.